THE ELECTRIC PENCIL

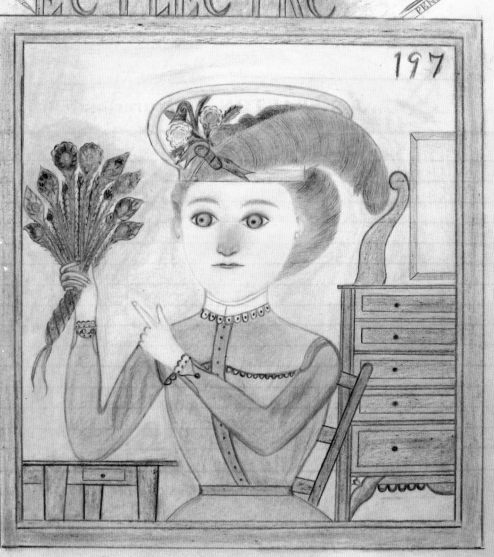

THE ELECTRIC PENCIL

DRAWINGS FROM INSIDE STATE HOSPITAL NO. 3

James Edward Deeds Jr.

introduction by
RICHARD GOODMAN

foreword by
HARRIS DIAMANT

PRINCETON ARCHITECTURAL PRESS · NEW YORK

FOREWORD

HARRIS DIAMANT

One day in 2006, trolling through eBay (as I'm wont to do), I made a fortuitous discovery. A handful of intriguing drawings appeared, and then, in front of my eyes, the listing was swiftly pulled. I embarked on a quest to track them down. The search eventually brought me to a once-in-a-lifetime treasure: an album of 283 masterful drawings in a handmade album. Each drawing had been executed on a ledger sheet with the imprimatur of "State Lunatic Asylum, No. 3" or "State Hospital No. 3," in Nevada, Missouri.

The artwork is a treasure trove of clues…a diary that tells a story in the artist's own personal symbolic language. The album and drawings look like artifacts from a distant time: arresting portraits of people with gaping eyes wearing nineteenth-century clothing, Civil War soldiers, antique cars, fantastic boats and trains, country landscapes with roaming animals, and other drawings that seem fanciful and bizarre. The oxidized edges of the old paper make the drawings look like treasure maps. The artist had hand made and hand bound this album of drawings with loving care.

Where the drawings were made was instantly apparent, but nothing else beside its beauty and uniqueness was known about this artwork. Researching

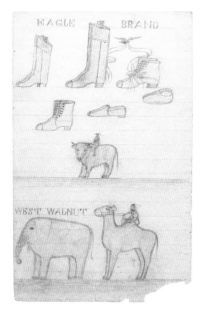

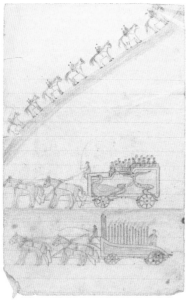

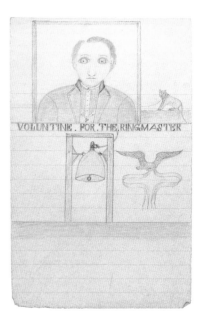

Three additional single-sided loose drawings were included
in the album.

the clues in the drawings brought up many other questions: Who was the artist? Was the artist a he or a she? When were the drawings created? What was the connection with State Lunatic Asylum No. 3?

As an artist, I was intrigued by the skillful, one could say obsessively, detailed draftsmanship of the work, each brick rendered with precision. The portraits are arresting, and despite the haunting faces, this is a peaceable world with no aggressive violence. The artist lovingly captured his subjects with a subtle use of color and shading, using the side of his pencil to create the smutty noses that enhance the modeling of the faces. The clothing and intimate objects of daily life are presented with solemnity and respect.

As a folk art and outsider art dealer and collector, I was thrilled by the discovery. I knew this was a singular work—rare and remarkable.

I began an adventurous search for the artist's identity, which led me to the Deeds family and the touching, disturbing life story of Edward Deeds, institutionalized for most of his adult life.

Amazingly, the album had been lost in 1970 and miraculously rescued by a fourteen-year-old boy, who kept it safe for thirty-six years until improbably, it came to light a second time, intact. I was able to acquire the collection, preserve and document the drawings, and embark on this journey of discovery. It is a gift and a miracle these drawings were saved.

Edward's story speaks to the human need to communicate—and the artist's need to make work in spite of horrendous circumstances. Looking at the well-worn covers, I envision Edward clutching the album like a talisman. I imagine the drawings were a source of comfort for him... a formal, gentle world he created as a sanctuary, a world in contrast to the harsh reality of his long life of abuse, hospitalization, and the frightening treatments he suffered at State Hospital Number 3. I am thrilled that Edward Deeds's wondrous art has found its own life on the world stage, telling a fanciful tale beyond the walls of the hospital and the tragic artist who was its creator.

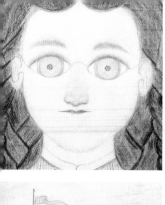
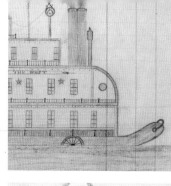
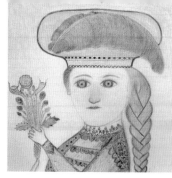
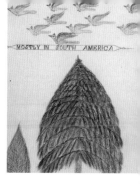

MOSTLY IN SOUTH AMERICA

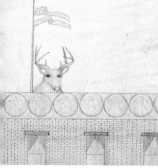
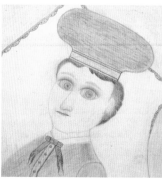
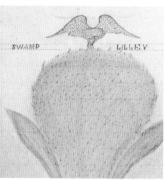

SWAMP LILLEY

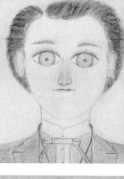

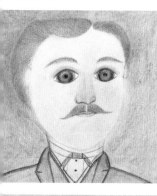
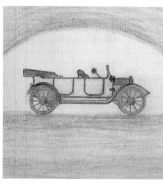
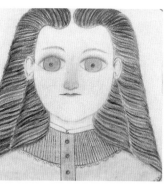
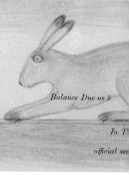

Balance Due us $

In T

official sec

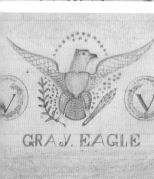

GRAY EAGLE

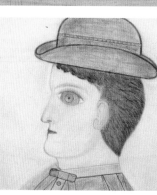
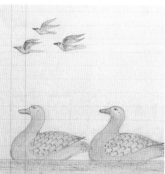
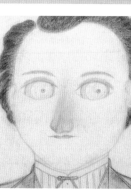

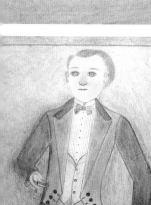

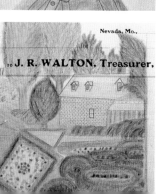

Nevada, Mo.,

TO J. R. WALTON, Treasurer,

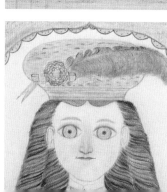

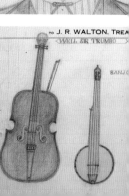

TO J. R. WALTON, TREA

WELL SIR TRUMBO

BANJO

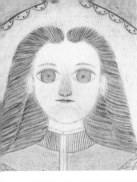
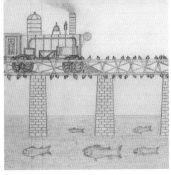
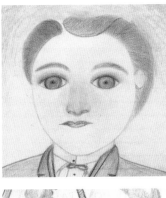
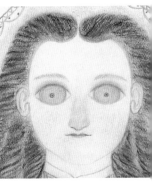

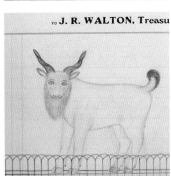
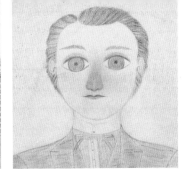
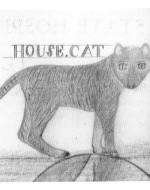
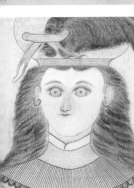
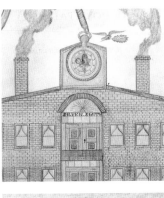
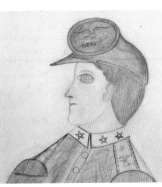
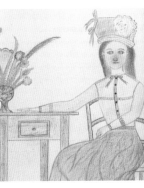
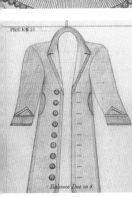
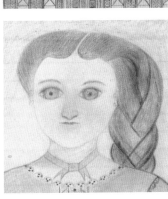
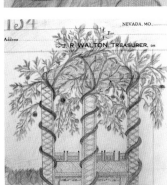
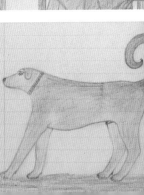
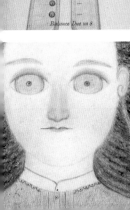
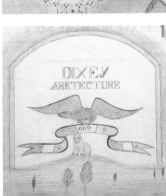
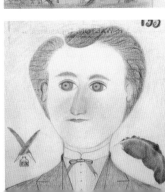
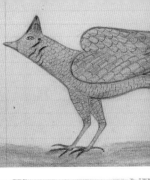

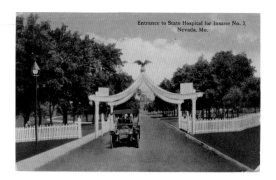

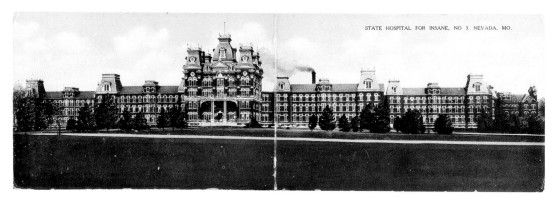

1 – Postcard, ca. 1920, of the entrance gate to State Hospital Number 3, in rural Nevada, Missouri, featuring the giant eagle sculpture depicted in Edward Deeds's drawings.

2 – Double postcard of the massive State Hospital Number 3. It was the largest building west of the Mississippi when it opened in 1887.

3 – Postcard of the reception hall of State Hospital Number 3. The goal of the asylum was to create a home and a haven for people suffering from mental illness.

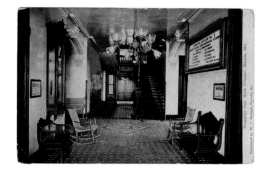

THE IMAGINED NOSTALGIA OF JAMES EDWARD DEEDS JR.

RICHARD GOODMAN

On June 7, 1936, a slender twenty-eight-year-old man with a ninth-grade education entered a massive, eight-wing brick structure in Nevada, Missouri. In its design and scale, this building would have fit in perfectly well in nineteenth-century London. It was as if the Victoria and Albert Museum had been set down on the outskirts of this small town in western Missouri. [**Figs. 1, 2, 3**] Except that it wasn't a museum. It was a hospital for the mentally ill. The man's name was James Edward Deeds Jr. He was admitted to State Hospital Number 3 in Nevada with a diagnosis of "dementia praecox." He was one of about seventeen hundred patients who lived in that building, some for a few months, some for years, some until they died. James

Edward Deeds Jr., called Edward by his family, would reside at State Hospital Number 3 for the next thirty-seven years. He would begin his residency during the height of the Great Depression and continue it through the first moon landing. He would know no other life than inside the walls of institutions. He would never marry, never father children, never own a house or a car, never travel, never walk through the world freely.

Yet, Deeds created an entire mysterious, enduring world with pen, pencil, crayons, and the discarded pages of a hospital ledger—and with his own unconfined imagination.

Edward Deeds and his art would have disappeared from history—and, in fact, until just recently, did—if it hadn't been for the scavenging

eye of a fourteen-year-old boy. Walking down a street in a residential section of Springfield, Missouri, one day in 1970, the boy spotted something in a trash heap. It was a worn, dull portfolio made of leather and cardboard. Its green and grayish cover had a patina of age and use. The boy pulled it from the trash. In it was something that must have astonished and befuddled him: 283 drawings that had been stitched crudely but resolutely into the book, along with three loose drawings. He would have immediately seen that the drawings were made on ledger paper labeled "State Hospital No. 3." There was no indication of who had made these drawings; there was no name on the book. They were strange yet purposeful, drawn with a fastidious delicacy. The boy had certainly never seen anything like them. No one had.

What did he make of the many drawings of large-eyed men and women staring straight at him as if they were transfixed, yet somehow not threatening? They were dressed in clothes he might have seen in black-and-white nineteenth-century formal photographs. What did he think of the drawings of animals, some drawn accurately, some awkwardly? Some were familiar—dogs, cats, ducks, and squirrels. Some he had only seen in books or in the zoo or at the circus—tigers, lions, elephants, and camels. He saw drawings of steamboats, smoke billowing out of smokestacks, and of old cars he might

have seen in silent films on TV. He saw clocks and fans, factory-like buildings and landscapes dotted with slim, tall trees. There was a baseball team in old-fashioned uniforms that might have especially caught his eye. There was a Wild West show.

The pages were all numbered by hand, but there didn't seem to be any order to the drawings. Some of the titles of the drawings were misspelled: *Bool Frog*, *Rucian*, *Professer*, *Wo Mule*, and *Southern Hotell*. He could see no reason why one drawing came after another. Nothing really happened in this book. There was no story. Some of the people had names, but nobody said anything. What was this? The boy had no idea that the man who made these drawings, Edward Deeds, was alive and living about one hundred miles away.

Something prompted the boy to take the battered portfolio home with him. Was it the benign calmness that emanated from the book? The simple oddness of it? Or was it that he knew somehow that this was a person's life's effort, a world that had been created with deliberation, care, and skill, and that leaving it there in the trash would have been wrong? We know the boy did, in fact, take the book home. He kept it for thirty-six years.

When he examined the contents more closely, he would have tallied sixty portraits of women and girls, many holding small, pretty posies and often wearing elaborate hats with fat plumes. If the women were without hats, their long hair

was inevitably parted precisely in the middle, streaming darkly and thickly behind each shoulder. He would have counted fifty-two portraits of men and boys, twenty-three of steamboats, six of early automobiles, and four of wood- or coal-fired trains. He saw factories with "Cotton Gin," "Silver Smith," and "Millionery Store" written on them by hand, the bricks of the squarish buildings drawn one by one, with near-scientific care. He turned the pages and saw airy drawings of watches and saw blades.

If there was one thing that these humans and animals, objects and landscapes had in common, it was that they all seemed to come from the world of his grandparents or great-grandparents. Through the ensuing years he would live with those drawings' many enigmas, not the least of which was: Who made them, and why?

In 2006 he decided, at last, to sell the album of drawings. We don't know exactly why. He contacted retired Missouri State University professor Dr. Lyndon Irwin, and Professor Irwin placed a few of the drawings on his website. A Kansas book dealer happened upon them and alerted his constituency. There was immediate interest from other dealers and collectors. The album of drawings was sold and then sold again. It eventually found its way into the hands of a New York City artist and collector, Harris Diamant. He had seen the drawings online and was instantly taken with them.

The boy—now a man, of course—who found the drawings? To further add to the unorthodoxy of this story, he has chosen to withdraw from its unfolding. In short, he's disappeared. We can only thank him for his faith and constancy and grant him his anonymity.

Harris Diamant, who, like everyone else, had no idea who the maker of these drawings was, gave him the name "the Electric Pencil," from the title of drawing number 197. Intrigued, Diamant was determined to find who the Electric Pencil was. He hired a detective in Missouri and placed articles and notices in a Springfield, Missouri, newspaper, with the story of the drawings and a call for anyone with information to please contact him.

By chance, one of Deeds's nieces, Julie Phillips, read one of the articles. From looking at reproductions of the drawings, she realized that this must be her Uncle Edward. Julie and her sister, Juanita, were the daughters of Edward's younger brother, Clay. Clay and his family would visit Edward once every four to six weeks at State Hospital Number 3. (Edward's mother would visit, too, but never his father.) Our knowledge of Deeds comes from Diamant's interviews with his nieces and subsequent research, along with Deeds's hospital records, released at his nieces' request, and other digging.

It is also because of the nieces that we have a few photographs of Edward Deeds, the Electric Pencil. In one, a slim man in a dark suit and short

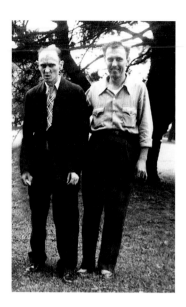

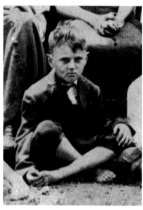

4 – Edward Deeds (left), with his younger brother, Clay Deeds, during a visit on the hospital grounds in 1944.

5 – Edward Deeds, age seven. Edward had a stormy childhood and was in conflict with his abusive father.

plaid tie stands on the hospital lawn, leaning forward, mouth agape. He is balding, with large ears, nose, and eyes. He looks straight at the camera, nearly blankly, much as the subjects of his portraits look at us. His hands are curled, his arms hang limply at his sides. [Fig. 4] This is the man who made the drawings that, for all their oddness and eccentricity, have many moments of delicate, soft precision, have an artistic vision. What does that say about what's inside all of us that can't be revealed in any photograph?

James Edward Deeds Jr. was born in 1908. [Fig. 5] He grew up on a farm in southwestern Missouri on the fringes of the Ozark Mountains, where he was the oldest of five children, three girls and two boys. From the beginning, he had difficulties learning. He was possibly autistic, and later, at State Hospital Number 3, it was determined he had an IQ just under eighty. He liked to spend time outdoors, in nature. His father, an authoritarian, wanted Edward to pull his weight on the farm. Edward resisted. This was a source of constant strife between the two, and so Edward became the object of his father's fierce anger. He would beat Edward "almost to death," as a niece put it.[1]

When physical force didn't work, Edward was made to live alone in a cabin on the farm's property, away from the main house, on the edge of a small river. What damage was done to Edward Deeds by his father? How much of Edward's

dream world was there from the beginning, and how much emerged on paper as a refuge from the violence he faced in childhood and the loneliness he would encounter later?

One day Edward threatened his younger brother, Clay, with a hatchet—it's not clear whether this was a serious gesture or a prank. That was enough. Deeds's father decided to send Edward away to the State School for the Feeble Minded in Marshall, Missouri, some three hours north of the farm. When Edward heard that he was going to be sent to Marshall and that he would be taken from his family, whom he truly loved, he tried to kill himself by drinking anti-freeze. Now, Edward would be completely alone among strangers. He was twenty-five.

He spent three years in the state school. Then, in 1936, he was labeled "insane" by the school—and therefore beyond its capabilities—and transferred to the massive State Hospital Number 3 in Nevada, Missouri, which had been built in 1887.

While we may think of mental hospitals of the nineteenth century as barbaric, for a while, at least in the United States, that wasn't the case. This was due in part to a compassionate Pennsylvania Quaker doctor named Thomas Kirkbride. Born in 1809, Kirkbride was a determined advocate for the humane treatment of the mentally ill. He founded the Association of Medical Superintendents of American Institutions for the Insane—the future American Psychiatric Association—and his influence was wide-ranging. Kirkbride's philosophy was that the mentally ill should be treated with kindness and respect. His reasons were not just moral but practical. "Of the recent cases of insanity, properly treated," he wrote, "between 80 and 90 percent recover."[2] A major part of his plan was contained in the design of the buildings where these patients would live. In 1854 he published *On the Construction, Organization and General Arrangements of Hospitals for the Insane*. It's a remarkable book.

No aspect of the hospital's design escaped his attention or failed to embody his concern for his patients' welfare, down to the water pipes, dust flues, and even the clothes hampers. His hospital would accommodate a maximum of 250 patients. "I know of no reason," he wrote in his book, "why an individual who has the misfortune to become insane, should, on that account, be deprived of any comfort or even luxury, that is not improper or injurious.…Everything repulsive and prison-like should be carefully avoided."[3] The building should be situated so that "the prevailing winds of summer may also be made to minister to the comfort of the inmates."[4] He considered every detail of the institution: "The floors of all patients' rooms, without exception, should be made of well seasoned wood.…There should be three marble or enameled cast iron wash

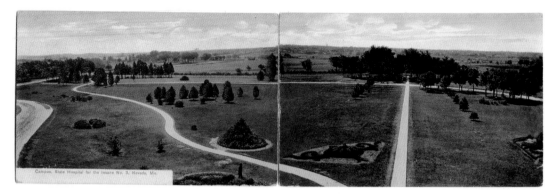

6 – Double postcard of the campus of State Hospital Number 3, featuring gardens, shade trees, and stately drives.

basins in one section of the bath room....The urinals should also be made of cast iron, well enameled, with a downward current of air through them."[5]

He even had an objection to the language and terms associated with the mentally ill: "'Lunacy' and 'lunatic' are terms," he wrote, "which have no meaning in reference to the diseases of the mind, and originated from a popular belief in influences that have long since been shown to have no existence."[6] Nearly one hundred hospitals across the United States were built according to the Kirkbride plan—at no little cost, which makes this even more astonishing. One of them is St. Elizabeths Hospital in Washington, DC, where one of our most famous poets was kept for twelve years, declared insane—Ezra Pound.

By the time Edward Deeds entered State Hospital Number 3, however, conditions had begun to deviate from Kirkbride's original specifications. Instead of 250 patients, the hospital population had burgeoned to some 1,700 souls. Set on 520 rich acres of land, the institution was self-sustaining. [Fig. 6] It had its own cows, chickens, and hogs that supplied milk, eggs, and meat. It grew its own vegetables. Every patient worked, some even as butchers. (Imagine the faith the staff must have had in the knife-wielding inmates.) Edward Deeds first worked in the fields and later at a more agreeable job for him, in the laundry room.

No one knows when Edward Deeds began to draw or why. The beginning of his drawing might well have coincided with a drastic change in the way patients with mental problems were treated in America. The 1950s brought the advent of tranquilizers such as Thorazine as a major part of the treatment of those afflicted. With those

16

drugs also came electroconvulsive therapy (ECT)—commonly known as shock therapy. A 1952 report by a psychologist working at State Hospital Number 3 is somewhat horrifying; the so-called therapies employed at the time included "Electric shock therapy; Metrazol and Insulin Shock Therapy; Fever Therapy; Hydo-Therapy; and Prefrontal Lobotomy." Last, and what appears to be least, was psychotherapy. The report goes on to say:

> Electric shock therapy is at the present time the most widely used form of treatment for mentally ill patients.... In the treatment a carefully regulated electric current is passed instantaneously through the brain, causing a reaction.... In this Hospital, Electric Shock Therapy is administered on a twice weekly basis or more or less frequently as the individual patient's condition warrants.[7]

Brynnan K. Light-Lewis, in her study of Deeds's life and art, describes what happened to Edward Deeds:

> While incarcerated at the State Hospital, Deeds was subjected to electroconvulsive therapy, a biomedical treatment in which an electric current is administered to a patient's brain. In the original method, known as sine-wave bilateral ECT, which is still widely used today, electrodes are placed on the scalp over each temporal region. In unilateral ECT, a single electrode is placed over the non-dominant hemisphere. The electric current induces a controlled convulsive seizure in an attempt to alleviate symptoms of psychiatric disorders.[8]

This brings us to one of the most poignant drawings in the album, number 33. It depicts a man with a smallish top hat and a sideways look, large nose, and thick lips. Below are written two words, in capital letters: *WHY. DOCTOR.* It also brings us back to drawing number 197 and the words written above a portrait of a feather-hatted lady pointing to a bouquet of flowers: *ectlectrc* and, in smaller letters on an angle to the side, *pencil.* Harris Diamant speculates that the misspelling of *electric* is not actually a misspelling at all, but rather a kind of cryptogram, with the letters *ECT*, twice rendered in the word, standing for "electroconvulsive therapy." The letters *ECT* can be found elsewhere: in drawing number 94, where they appear on the face of a multiwindowed building, and in drawing number 95, below a portrait of a man wearing a fedora. Beneath the portrait is a cigar-shaped object, which Diamant speculates might be a device put in patients' mouths when they were given shock therapy so they wouldn't bite their tongues when convulsed.

With that brave new world of therapies, Edward Deeds's life changed in State Hospital

Number 3. On the one hand, he would have been stupefied daily with sedatives. Then, probably twice a week, he would have been subjected to massive jolts of electricity to his cortex. In between these two seemingly contradictory therapies, each brutal in its own way, he would have experienced long periods of nothing. A mental hospital does not have a social director on a constant mission to stimulate and entertain people; there are hours and hours of sitting and staring, of a listlessness that encourages still more listlessness.

Draw Edward Deeds did, though. He drew meticulously wrought pictures on "State Hospital No. 3" ledger paper that had once belonged to a "J. R. Walton, Treasurer." At the bottom of the page, in blunt, small type, is printed "Balance Due us, $." But what we see on these pages has nothing to do with money, with accounts due. What we see are vines curling around trellises then bursting into petite yellow, pink, and lavender flowers; a solitary lion and tiger looking right at us like a pencil-rendered version of Edward Hicks's *Peaceable Kingdom*; we see a dandy in tails with the snappy title *Hello.Kid*; we see an opened fan, its bands as consistently and finely rendered as a chambered nautilus; we see an almost effervescent hot-air balloon, its tether trailing downward like an afterthought; we see five full-length portraits of ladies in fashionable ankle-length dresses.

In fact, the men and women in Deeds's world are always dressed in their best. They all seem ready to attend some sort of formal or celebratory affair—perhaps a dance or an afternoon tea or a voyage somewhere or a church service. No one in Deeds's world is slovenly, crude, aggressive, or ugly. No one is mocked, lampooned. No one hurt or damaged. There are no deaths. It is a picturesque, orderly world. If this is a manifestation of his subconscious, then he must have been a kind-hearted man. He was someone who, despite his bleak surroundings and his hard background, created a serene, sweet world. For the most part, it's a world of individuals—people, animals, cars, trains, and steamboats are rendered uniquely. This, like all art, is the creation of a single spirit. It's a world of "real toads in imaginary gardens," as the poet Marianne Moore put it. This is where Edward Deeds truly and fully lived. This manifests the strength of art.

Here, in this atmosphere of boredom and loneliness, Deeds began to draw not the life around him but a world he had never experienced. What era is this? What time in American history? It's clearly not the 1930s, when Deeds entered the hospital. Nor is it the 1920s. It's earlier. The clues are in the automobiles and in, of all things, the shoes. Scot Keller, chief curator of LeMay–America's Car Museum in Tacoma, Washington, commented on scans of the six automobiles Deeds drew:

The singular shot [drawing number 6] looks to be pure imagination. The shapes and lines don't look like any car that we recognize. [Drawing number 2] has some elements of the [Ford] Model T but, given the sheer number of cars built in that time period, it is natural that a drawing would use some T elements. [Drawing number 47] is a fairly accurate depiction of…many cars of that era, but there isn't enough to identify it as a specific brand.[9]

Henry Ford began producing his iconic Model T in 1908 and stopped in the 1920s.

It's the shoes that help most in terms of trying to pin down the time of Deeds's world. H. Kristina Haugland, associate curator of costume and textiles at the Philadelphia Museum of Art, looked at drawing number 89, which Deeds titled *Miss Ausburn*, and drawing number 151, which he labeled *At the Garden Gate*, both full-length portraits of women in plumed hats and long-sleeved, ankle-length dresses:

> The two images feature rather idiosyncratic dress that seems to be from the late nineteenth or early twentieth century but is not specifically datable to a particular time. The footwear, however, is very detailed; as Nancy E. Rexford's book *Women's Shoes in America, 1795–1930* makes clear, footwear styles can be fairly easy to date. Judging from the shoes, and consistent with everything else in the images, I would say that the images

may date to the first decade of the twentieth century. (This is also in keeping with the shape of the torso of the woman in profile, which seems to have the "monobosom" look prevalent in the years around 1905.)[10]

So: 1900 to 1910, more or less. In addition, Deeds drew quite a few steamboats, and we know that steamboats plied the Mississippi into the early part of the twentieth century. The one figure Deeds drew that seems to have a counterpart in real life—Champ Clark, a member of the US Congress, depicted in drawing number 157—lived until 1921.

In the end, the most important aspect of this era is that it was not Edward Deeds's era. It was the world that flourished at the time of his birth and perhaps ten or fifteen years before and after. It's a world of *imagined nostalgia*. The fact that it doesn't really exist in any specific historical context *is* the point. Lady Smith, Lady York, Miss Winterstine, Miss Snider, Miss Fanny, and all the other men and women he names may somewhere exist in fashion, theater, local history, or literature. But where they certainly *do* exist, and will always exist, is on the pages Deeds created. This is a world of the imagination. The moment we relinquish the desire to find "real" counterparts to Edward Deeds's men and women, landscapes, trains, and cars is the moment we elevate Edward Deeds's work from some kind of curiosity to art.

There are some mysteries, though—some tantalizing things in these drawings that we can't avoid. The twenty-three steamboats he drew, for example, came from somewhere we don't know. The closest river to State Hospital Number 3 was the 102-mile-long Marmaton, too narrow for steamboat travel. The river near his boyhood home, the Finley, is even smaller. It's not a great leap, though, to think of that most famous of Missouri towns, known throughout the world—Hannibal. And to remember Mark Twain's excited evocation of steamboats and the majestic joy they brought to his world. Steamboats glorify both *The Adventures of Huckleberry Finn* and *Life on the Mississippi.* Had Edward Deeds read *Huckleberry Finn* (or had it read to him)? In any case, it would be nearly impossible to grow up in Missouri without some idea of the role steamboats played in the state's history. How could you escape the infectious romanticism?

In the end, though, Edward Deeds's iconography will probably remain as private and elusive as the man himself.

Edward Deeds drew with pen, pencil, and crayon. His palette was limited. His favorite color was green—a faint, lightly assertive shade of green. He also employed soft, muted yellows, reds, blues, and browns. We don't know if this was by choice or by necessity. His mother would bring him crayons when she visited, but we don't know the range of hues. In fact, the most prominent colors in the portfolio are pencil-gray and black. Deeds's coloring is often subtle, not to mention his draftsmanship. You can miss this at first if your eye is waylaid by the small-pupiled, big-eyed men and women staring straight at you hypnotically. But look at drawing number 87, called *Miss. Arnnell*—look at the stream-like accentuations on her dress, the intricacy of the hem, the chevron-shaped flower arrangement. Look at the peacock's vivid eyes in drawing number 30; the minuscule minutes of the watch face in drawing number 63; the fretless yellow banjo in 72, its strings angled ever so slightly inward from the bridge; the horse's hooves, driver's snappy hat and parabola-shaped whip in midair in 122; look at the Le Nôtre–like formal garden in 144; the back legs of the frowning frog in 228; the surely linked anchor chains in 262.

It's good to remember that these are drawings, not paintings. Their pleasures are those we receive from viewing drawings, and those pleasures are not the same as those we receive viewing paintings. Sometimes when we look at the drawings of famous painters, we seem to be looking at the work of a different artist. The limited range of colors is what often makes the work so wonderful: how much these artists can render from so little. We understand that what the pen and pencil can do, the brush can't.

His nieces knew their uncle liked to draw, but neither they nor Clay Deeds knew he had

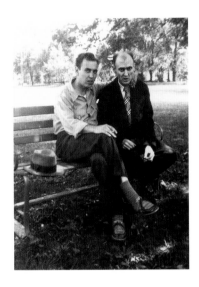

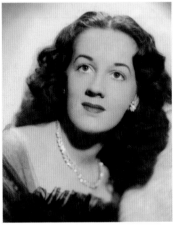

7 – Clay Deeds (left) visiting his brother, Edward Deeds. The family made the trip every few weeks, often picnicking on the grounds of the hospital.

8 + 9 – Clay's wife, Martaun Smith Deeds. Family identified Edward Deeds's "Miss. Martin" (drawing number 64) as a portrait of his sister-in-law.

created anything like the album's 283 drawings—and possibly more. He looked forward to the visits from Clay, his wife, Martaun, and their daughter Juanita. [**Figs. 7, 8**] We know he was despondent when they left. We can imagine him afterward walking back to his room. We can imagine the comfort he had putting pencil or crayon to paper, the reassurance and affirmation of creating, assuaging despair and loneliness. He was drugged and shocked, yet look what he created! Look at the peaceable Midwest kingdom, the docile Henri Rousseau–like world of tigers, plumed hats, and wispy trees. How can you not think of the haven art can provide and of its determination to be revealed? Or of the beauty and strength of the human spirit? "The violets in the mountains," as Tennessee Williams wrote, "have broken the rocks."

Sometime in the mid-1960s, Deeds decided to give the album he had made of his drawings to his mother. Arthritis had made it difficult for him to draw. We don't know what she thought of her son's handiwork. We know she loved him, was loyal to him, cared about him. However, when she became infirm and was moved to a nursing home, she gave the album to her other son, Clay, who placed it in his attic. Clay and his family eventually moved from their home in Springfield, and, during the transition, Clay mistakenly told the movers they could take whatever they wanted from the attic. The movers cleaned the space out,

and, seeing no use for an album of strange drawings, they tossed it in a trash heap on the side of the road. The drawings shouldn't have been found. But they were.

How will Edward Deeds's work be viewed, classified, appreciated, now that it's in the world? Deeds will be inevitably—has been already—referred to as an "outsider artist." He will be discussed alongside other outsider artists such as James Castle, Henry Darger, Martín Ramírez, and Howard Finster.

The idea of "outsider art"—although certainly not the actual practice—has its modern origins with Jean Dubuffet, who called it *art brut*, writing:

> By this we mean pieces of work executed by people untouched by artistic culture, in which therefore mimicry, contrary to what happens in intellectuals, plays little or no part, so that their authors draw everything (subjects, choice of materials employed, means of transposition, rhythms, ways of writing, etc.) from their own depths and not from clichés of classical art or art that is fashionable. Here we are witnessing an artistic operation that is completely pure, raw, reinvented in all its phases by its author, based solely on his own impulses.[11]

Many artists probably wouldn't have been discovered or exhibited were it not for this

classification that has allowed art critics and gallery owners to feel secure in buying and selling such nonclassic art. The famous outsider artist Martín Ramírez, who spent thirty-two years in California mental hospitals, left a legacy remarkably close to what Edward Deeds has left us, from nearly the same origins. Ramírez was institutionalized in 1931, just five years earlier than Deeds, first in California's Stockton State Hospital and later in the DeWitt State Hospital. *New Yorker* art critic Peter Schjeldahl offers illuminating words in describing him, words that can just as well apply to James Edward Deeds:

> Outsider art—lately euphemized as "self-taught," a vapid label that inconveniently describes originality in general—comes from and goes nowhere in art history. (The outsider is a culture of one.) It defeats normal criticism's tactics of context and comparison. It is barbaric. Can we skirt the imbroglio and regard Ramírez as an ordinary artist with extraordinary qualities?…What is it like to be an outsider? Outside what? Ramírez worked cogently from within his memory, imagination, and talent. He also belonged to an actual culture, that of a mid-century American mental hospital.…He surely suffered, but his subject was an accessible happiness.[12]

It might be well to eliminate the term *outsider artist* and refer to Edward Deeds as, in Schjeldahl's words, "a culture of one." We may know what the term *outsider art* means, but doesn't *outside* have a negative concept? If we're going to use any term at all, it might be more appropriate to call the drawings of Edward Deeds "insider art." He created his art inside an institution. He was never outside.

On January 12, 1973, having been declared no longer a danger to self and to others, James Edward Deeds Jr. was transferred from State Hospital Number 3 to the Christian County Nursing Home in Ozark, Missouri, not far from the farm where he grew up. He died fourteen years later, on January 9, 1987, at the age of seventy-eight. He's buried nearby.

State Hospital Number 3 was closed in 1991 and torn down in 1999. Thomas Kirkbride's great plan for the welfare of the mentally ill may have been altered by modern drugs and machines. But even under that assault, Edward Deeds managed, through his sweet, enigmatic art, not only, in Faulkner's words, to endure, but to prevail.

NOTES

1 Brynnan K. Light-Lewis, "The Deeds of Outsider Art" (master's thesis, Sotheby's Institute of Art, 2012), 8, http://www.electricpencildrawings.com/pdf/thesis.pdf.

2 Thomas S. Kirkbride, *On the Construction, Organization and General Arrangements of Hospitals for the Insane* (Philadelphia: s.n., 1854), 2.

3 Ibid., 5, 12.

4 Ibid., 12.

5 Ibid., 16, 20, 21.

6 Ibid., 73.

7 *The First One Hundred Years of Mental Health Services, 1885–1985: Nevada State Hospital and Nevada Habilitation Center* (Nevada, MO: s.n., 1985), 46–48.

8 Light-Lewis, 44.

9 Scot Keller, e-mail to author, January 15, 2015.

10 Kristina Haugland, e-mail to author, January 28, 2015.

11 Jean Dubuffet, "L'art brut préféré aux arts culturels" (Paris: Galerie René Drouin, 1949).

12 Peter Schjeldahl, "Mystery Train," *New Yorker*, January 29, 2007, 88–89.

I would like to thank Neville Bean, Kristina Haugland, and Scot Keller for their help in researching the art and life of Edward Deeds. I'd like to thank Deborah Attoinese, John Hazlett, and Alex Jones for their encouragement. I want to especially thank Leslie Staub for her apt, insightful comments and suggestions and for a haven in which to write.

—Richard Goodman

Richard Goodman is the author of *French Dirt: The Story of a Garden in the South of France*, *The Soul of Creative Writing*, *A New York Memoir*, and *The Bicycle Diaries: One New Yorker's Journey Through 9/11*. He has written for the *New York Times*, *Creative Nonfiction*, *Harvard Review*, *River Teeth*, *Chautauqua*, *Vanity Fair*, *Ascent*, *French Review*, and *Michigan Quarterly Review*. He is an assistant professor of creative nonfiction writing at the University of New Orleans. His website is www.richardgoodman.org.

DRAWINGS FROM INSIDE STATE HOSPITAL NO. 3

A NOTE ON THE DRAWINGS:
The original drawings reproduced in this catalogue are approximately
9.25 × 8.25 inches, and they are shown here in the sequence of Edward Deeds's album.
Each two-sided leaf represents the two sides of a page of that album; the first
and last two plates are the album's covers.

JEWEL QUILT.

508

PATT

SIZE

STATE HOSPITAL NO. 3.

NEVADA, MO., _____ 190___

Address _____ } For _____

TO J. R. WALTON, TREASURER, DR.

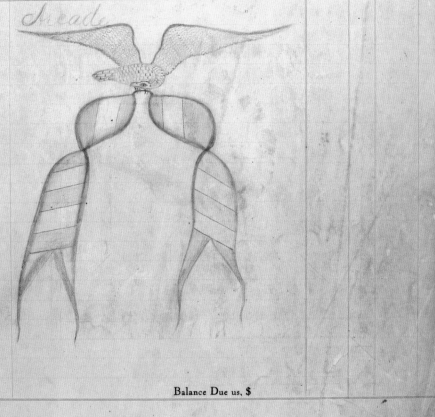

Balance Due us, $

IN TESTIMONY WHEREOF, I hereunto set my hand and affix
my official seal, this _____ day of _____ 190___

Superintendent.

Please Return This Statement When You Remit.

J. R. WALTON, Treasurer

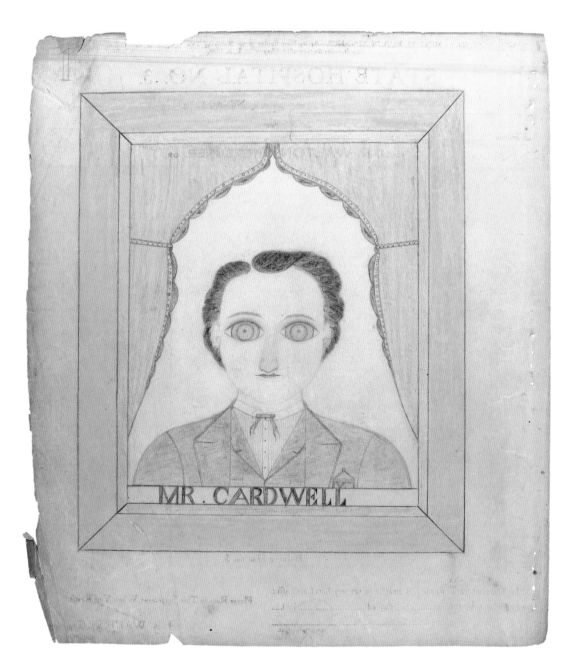

MR. CARDWELL

STATE HOSPITAL NO. 3.

2

NEVADA, MO.,_____190__

_____ } For _____

Address _____

TO J. R. WALTON. TREASURER, DR.

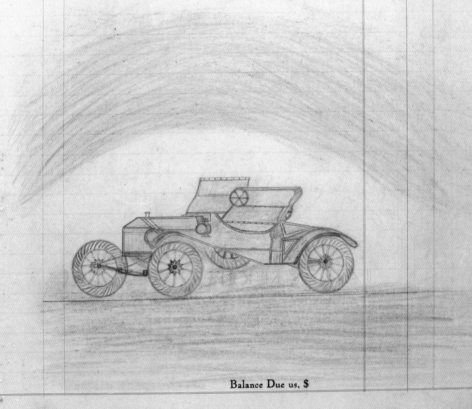

Balance Due us, $

IN TESTIMONY WHEREOF, I hereunto set my hand and affix
my official seal, this_____day of_____190____

Superintendent.

Please Return This Statement When You Remit.

J. R. WALTON, Treasurer.

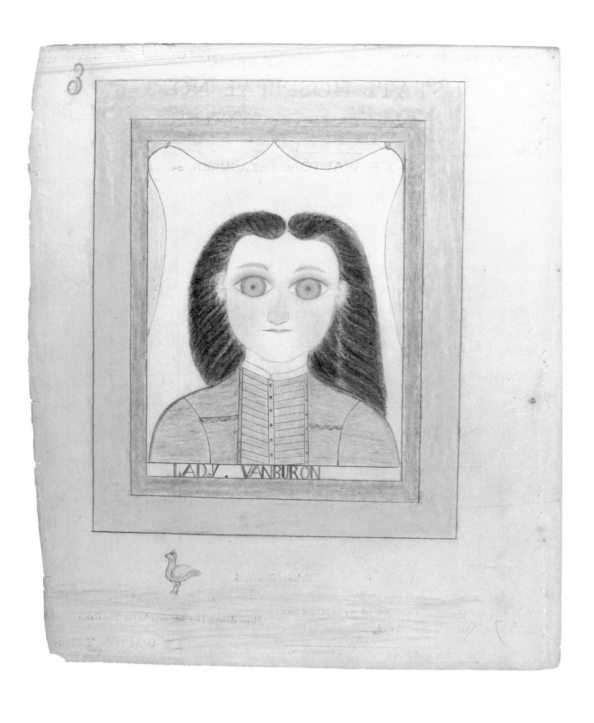

LADY VANBURON

State Hospital No. 3.

4

Nevada, Missouri, _____ 190____

_____ } for _____

Address _____

TO J. R. WALTON, Treasurer, DR.

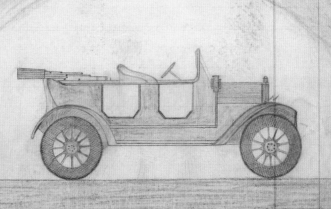

Balance Due us $

In Testimony Whereof, I hereunto set my hand and affix

my official seal, this_____ day of_____ 190____

_____ *Superintendent*

Please Return This Statement When You Remit,

J. R. WALTON, Treasurer.

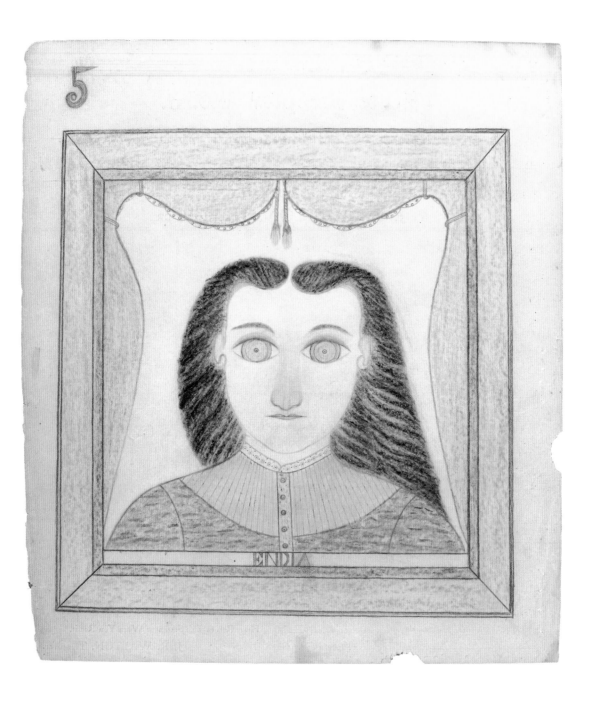

State Hospital No. 3.

Nevada, Missouri,_____190____

Address _____ } for _____

TO J. R. WALTON, Treasurer, DR.

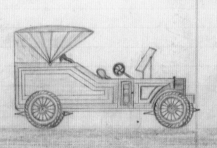

Balance Due us $ _____

In Testimony Whereof, I hereunto set my hand and affix
my official seal, this_____day of _____190____

_____*Superintendent*

J. R. WALTON, Treasurer.

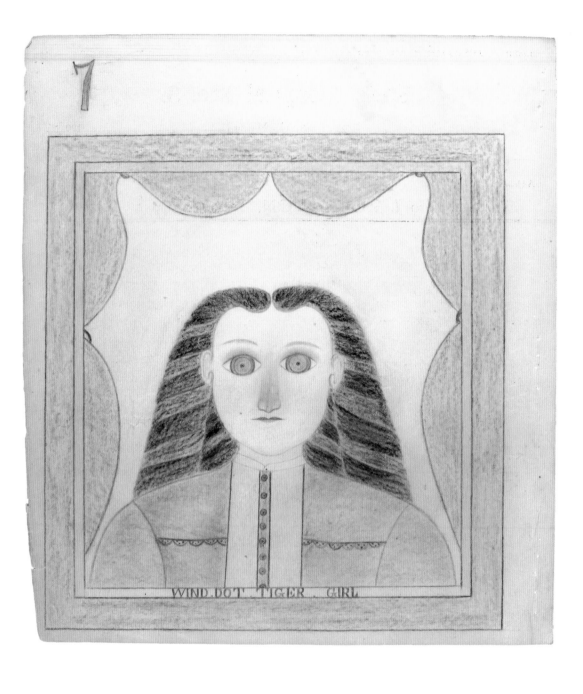

WIND DOT TIGER GIRL

State Hospital No. 3.

Nevada, Missouri, _____ 190____

8

Address _____ } for _____

TO J. R. WALTON, Treasurer, DR.

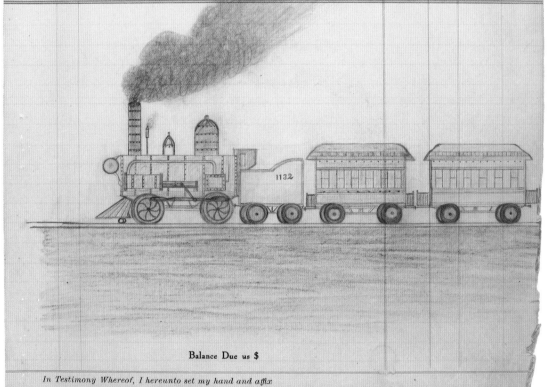

1132

Balance Due us $

_In Testimony Whereof, I hereunto set my hand and affix my official seal, this_____ day of_____190____

_____Superintendent

Please Return This Statement When You Remit.

J. R. WALTON, Treasurer.

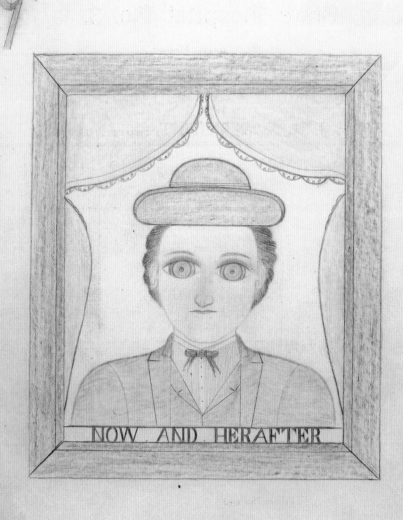

NOW AND HERAFTER

STATE HOSPITAL NO. 3.

NEVADA, MO.,_____190___

Address_____ } For _____

то J. R. WALTON, TREASURER, DR.

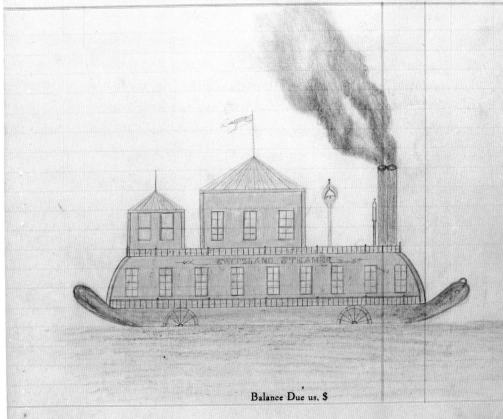

Balance Due us, $

In Testimony Whereof, I hereunto set my hand and affix
my official seal, this_____day of_____190___

Superintendent,

Please Return This Statement When You Remit.

J. R. WALTON, Treasurer.

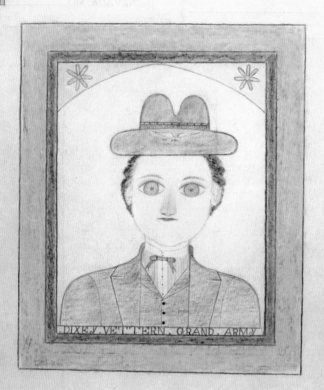

STATE HOSPITAL NO. 3.

NEVADA, MO.,_____190__

12

Address_____ } For_____

TO J. R. WALTON, TREASURER, DR.

Balance Due us, $

IN TESTIMONY WHEREOF, I hereunto set my hand and affix my official seal, this_____day of_____190____

Superintendent.

Please Return This Statement When You Remit.

J. R. WALTON, Treasurer.

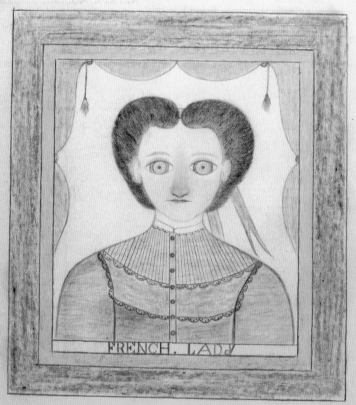

FRENCH. LADY.

State Hospital No. 3.

Nevada, Missouri, _____ 14 _____ 190___

_____ } for _____

Address _____

TO J. R. WALTON, Treasurer, DR.

Balance Due us $

In Testimony Whereof, I hereunto set my hand and affix

_my official seal, this_____ _day of_____ _190___

_____ _Superintendent_

Please Return This Statement When You Remit,

J. R. WALTON, Treasurer.

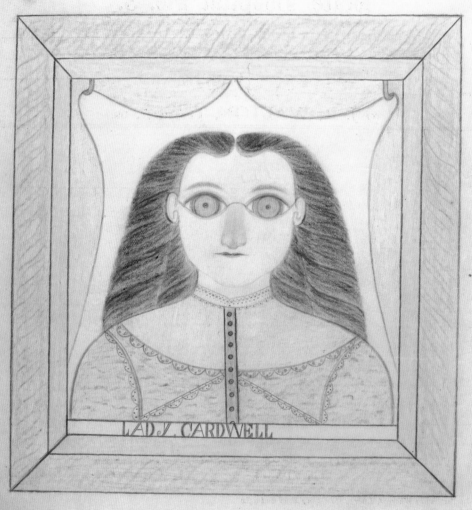

LADY CARDWELL

State Hospital No. 3.

Nevada, Missouri, _____ 16 190____

_____ } for _____

Address _____

TO J. R. WALTON, Treasurer, DR.

SWAN

Balance Due us $

In Testimony Whereof, I hereunto set my hand and affix

my official seal, this_____ day of _____ 190___

_____ *Superintendent*

Please Return This Statement When You Remit,

J. R. WALTON, Treasurer.

17

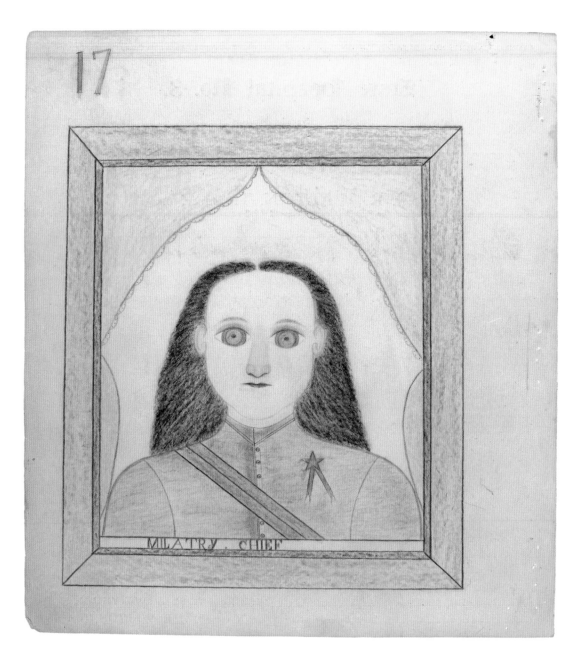

MILA'TRY . CHIEF

State Hospital No. 3.

Nevada, Missouri, _____ 190___

WITCHATAUGAH RIVER

_____ } for _____

Address _____

TO J. R. WALTON, Treasurer, DR.

Balance Due us $

In Testimony Whereof, I hereunto set my hand and affix

my official seal, this _____ _day of_ _____ 190___

_____ _Superintendent_

Please Return This Statement When You Remit,

J. R. WALTON, Treasurer.

19

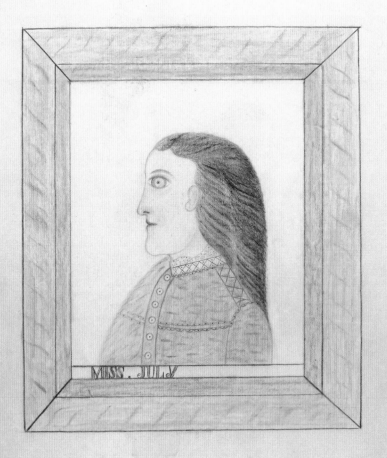

MISS. JULY

State Hospital No. 3. *20*

Nevada, Missouri, _____ 190___

Address _____ } for _____

TO J. R. WALTON, Treasurer, DR.

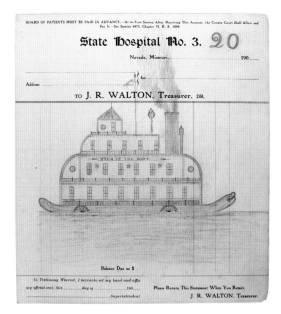

Balance Due us $ _____

In Testimony Whereof, I hereunto set my hand and affix

my official seal, this_____ day of_____ 190_. Please Return This Statement When You Remit.

_____ Superintendent J. R. WALTON, Treasurer.

State Hospital No. 3. *22*

Nevada, Missouri, _____ 190___

Address _____ } for _____

TO J. R. WALTON, Treasurer, DR.

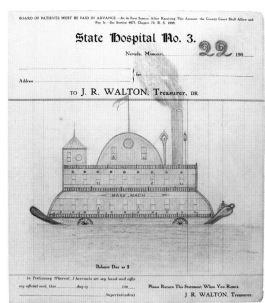

Balance Due us $ _____

In Testimony Whereof, I hereunto set my hand and affix

my official seal, this_____ day of_____ 190_. Please Return This Statement When You Remit.

_____ Superintendent J. R. WALTON, Treasurer.

State Hospital No. 3. *24*

Nevada, Missouri, _____ 190___

Address _____ } for _____

TO J. R. WALTON, Treasurer, DR.

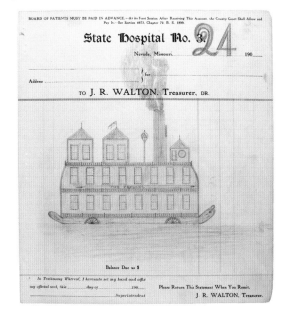

Balance Due us $ _____

In Testimony Whereof, I hereunto set my hand and affix

my official seal, this_____ day of_____ 190_. Please Return This Statement When You Remit.

_____ Superintendent J. R. WALTON, Treasurer.

State Hospital No. 3. *26*

Nevada, Missouri, _____ 190___

Address _____ } for _____

TO J. R. WALTON, Treasurer, DR.

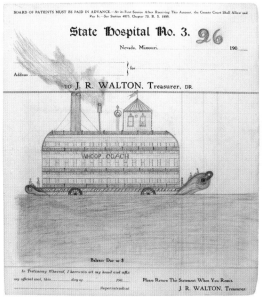

Balance Due us $ _____

In Testimony Whereof, I hereunto set my hand and affix

my official seal, this_____ day of_____ 190_. Please Return This Statement When You Remit.

_____ Superintendent J. R. WALTON, Treasurer.

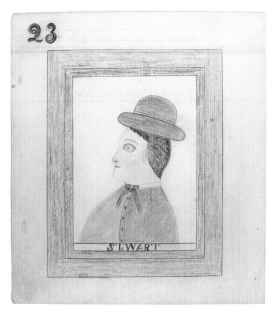

23

N.º EWART

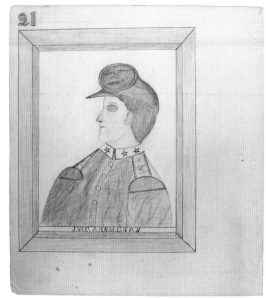

21

J.W.C.A.S.M.GRAY

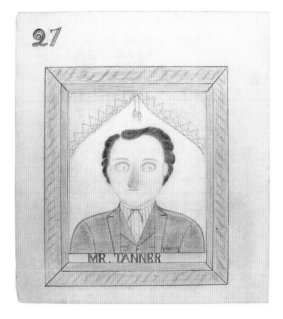

27

MR. TANNER

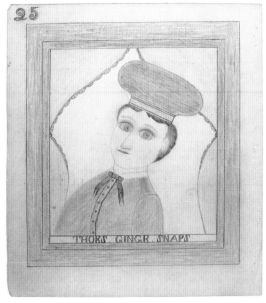

25

THOES. GINGR. SNAPS

State Hospital No. 3. 28

Nevada, Missouri,_____ 190____

_____ } for _____

Address _____

TO **J. R. WALTON**, Treasurer, DR.

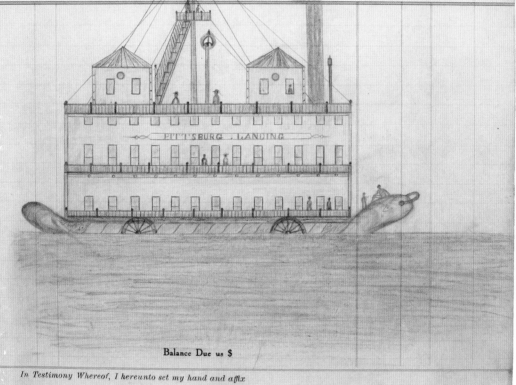

Balance Due us $

In Testimony Whereof, I hereunto set my hand and affix

my official seal, this_____ day of_____ 190____ Please Return This Statement When You Remit,

_____ *Superintendent* **J. R. WALTON**, Treasurer.

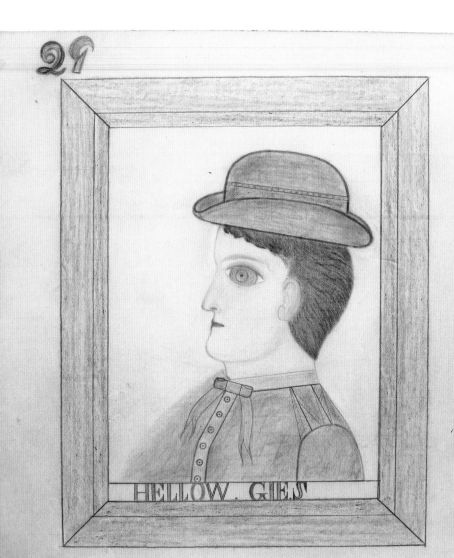

HELLOW GES

State Hospital No. 3.

30

Nevada, Missouri,_____ 190____

_____ } for _____

Address _____

TO J. R. WALTON, Treasurer, DR.

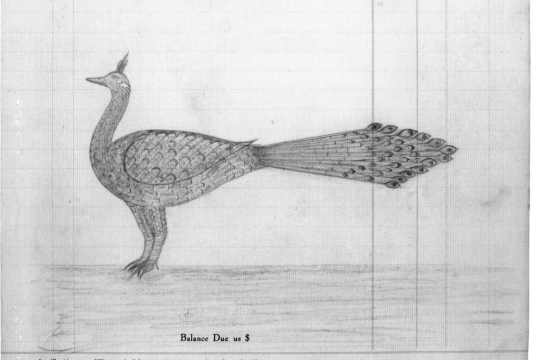

Balance Due us $

*In Testimony Whereof, I hereunto set my hand and affix my official seal, this*_____ *day of*_____ *190*____

_____ *Superintendent*

Please Return This Statement When You Remit,

J. R. WALTON, Treasurer.

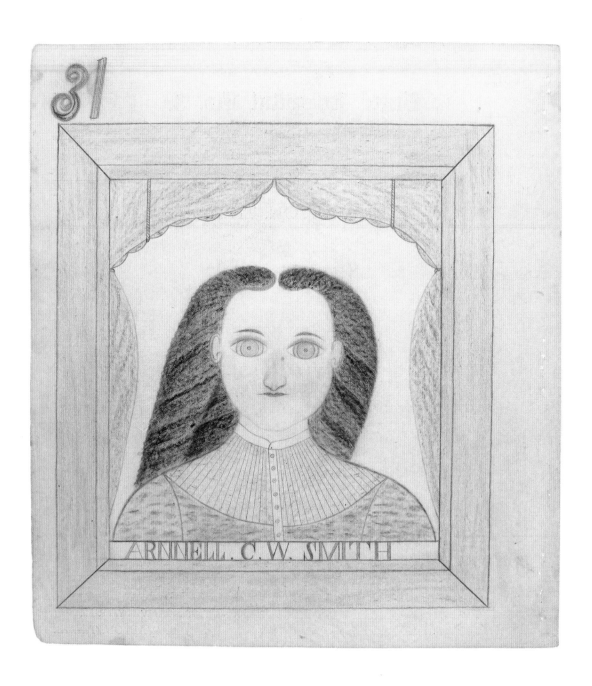

ARNNELL. C. W. SMITH

State Hospital No. 3.

Nevada, Missouri,_____ 190____

32

} for

Address _____

TO J. R. WALTON, Treasurer, DR.

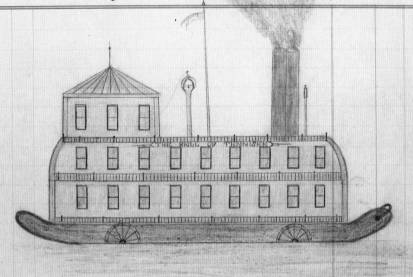

Balance Due us $

In Testimony Whereof, I hereunto set my hand and affix my official seal, this_____ day of_____ 190____

_____ *Superintendent*

Please Return This Statement When You Remit.

J. R. WALTON, Treasurer.

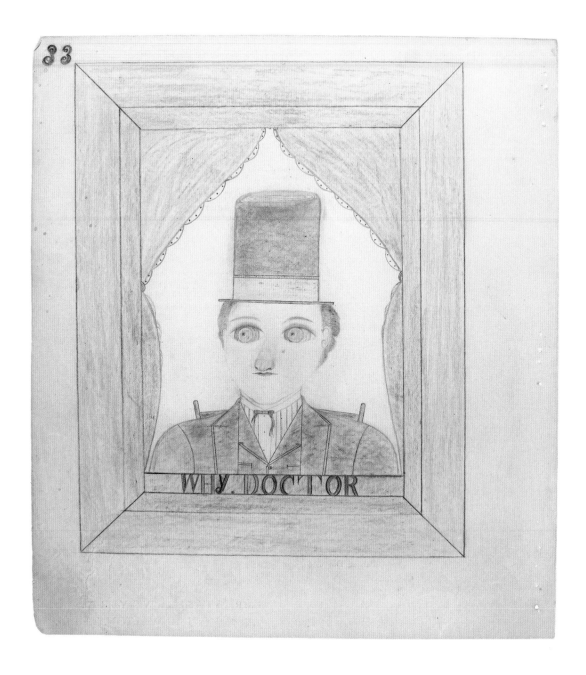

State Hospital No. 3. 34

Nevada, Missouri, _____ 190____

_____ } for ._____

Address _____

TO J. R. WALTON, Treasurer, DR.

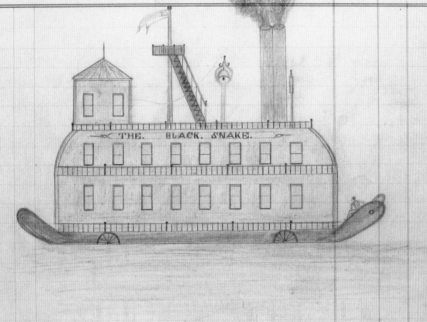

Balance Due us $

In Testimony Whereof, I hereunto set my hand and affix

my official seal, this_____ day of_____ 190___ Please Return This Statement When You Remit,

_____ Superintendent J. R. WALTON, Treasurer.

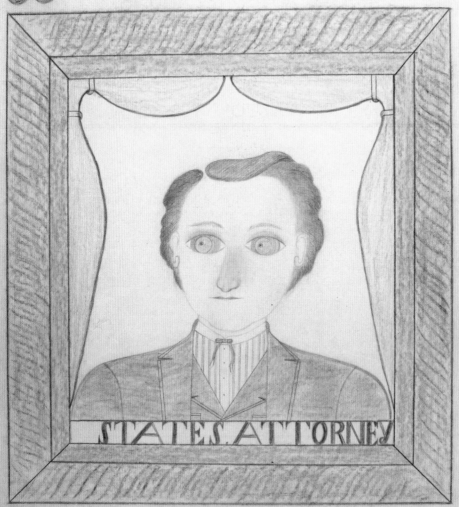

State Hospital No. 3.

36

Nevada, Missouri,_____ 190____

}for_____

Address _____

TO J. R. WALTON, Treasurer, DR.

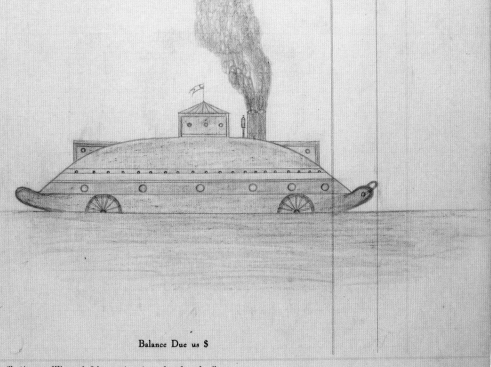

Balance Due us $

In Testimony Whereof, I hereunto set my hand and affix

*my official seal, this*_____*day of*_____*190*____

_____*Superintendent*

Please Return This Statement When You Remit,

J. R. WALTON, Treasurer.

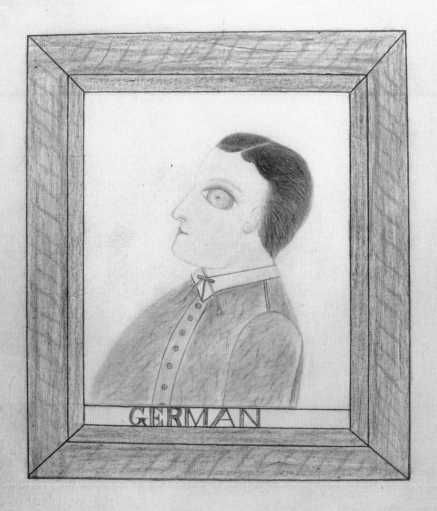

GERMAN

State Hospital No. 3. 38

Nevada, Missouri,_____ 190____

_____ } for _____

Address _____

TO J. R. WALTON, Treasurer, DR.

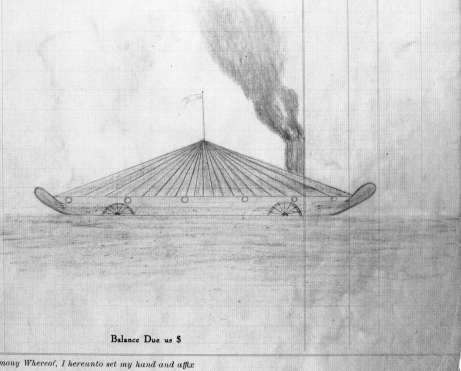

Balance Due us $

In Testimony Whereof, I hereunto set my hand and affix my official seal, this_____day of_____190____

_____ *Superintendent*

Please Return This Statement When You Remit,

J. R. WALTON, Treasurer.

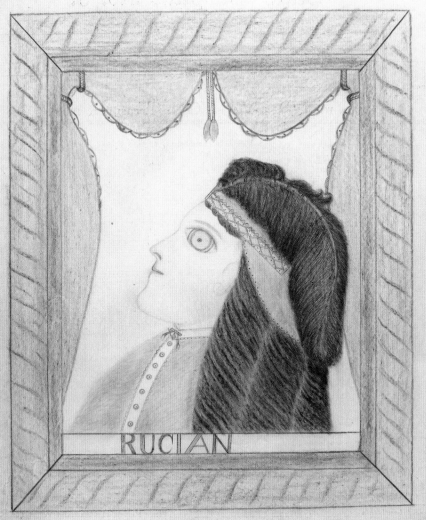

RUCIAN

STATE HOSPITAL NO. 3.

40

NEVADA, MO., _____ 190__

Address _____ } For _____

TO J. R. WALTON, TREASURER, DR.

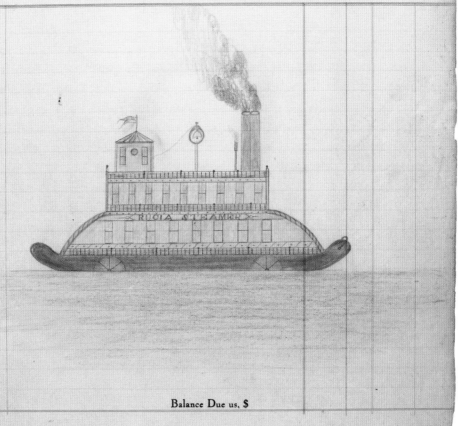

Balance Due us, $ _____

IN TESTIMONY WHEREOF, I hereunto set my hand and affix
my official seal, this _____ day of _____ 190__

...
Superintendent.

Please Return This Statement When You Remit.

J. R. WALTON, Treasurer.

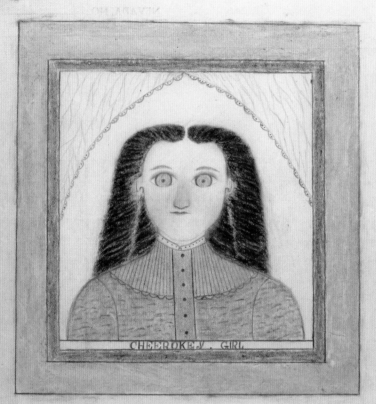

CHEEROKEY GIRL

STATE HOSPITAL NO. 3.

42

NEVADA, MO., _____ 190___

Address _____ } For _____

TO J. R. WALTON. TREASURER, DR.

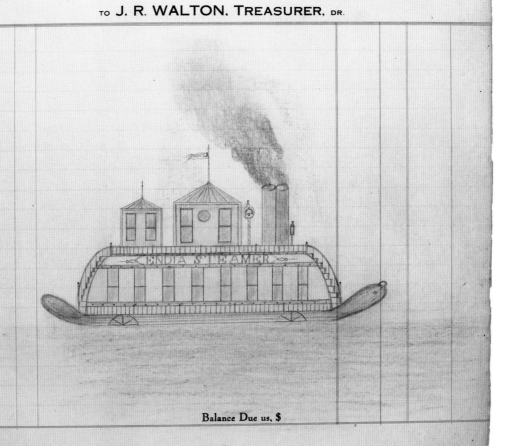

Balance Due us, $ _____

IN TESTIMONY WHEREOF, I hereunto set my hand and affix my official seal, this_____day of_____190___

Superintendent.

Please Return This Statement When You Remit.

J. R. WALTON, Treasurer.

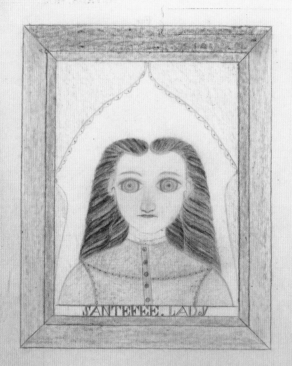

WANTEFEE. LADY

State Hospital No. 3.

Nevada, Missouri,_____ 44 190___

_____ } for _____

Address _____

TO J. R. WALTON, Treasurer, DR.

Balance Due us $

In Testimony Whereof, I hereunto set my hand and affix

*my official seal, this*_____ *day of*_____ 190____ Please Return This Statement When You Remit,

_____ Superintendent J. R. WALTON, Treasurer.

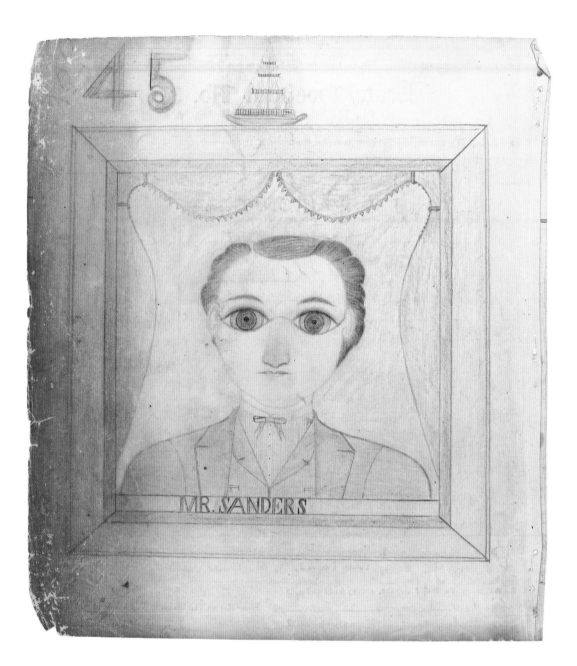

MR. SANDERS

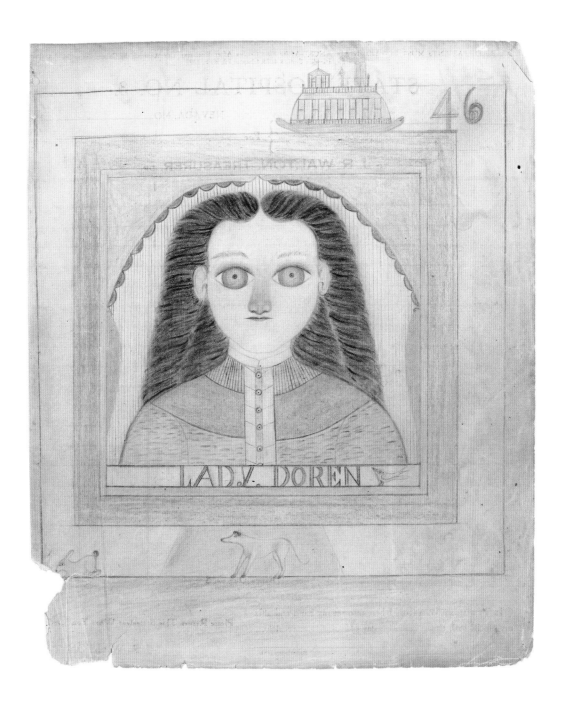

LADY DOREN

47 STATE HOSPITAL NO. 3.

NEVADA, MO.,————————— 190

Address ———————————————— } For ————————————

TO **J. R. WALTON, TREASURER,** DR.

Balance Due us, $

IN TESTIMONY WHEREOF, I hereunto set my hand and affix my official seal, this————————day of————————190——

———————————————————
Superintendent.

Please Return This Statement When You Remi

J. R. WALTON, Tr

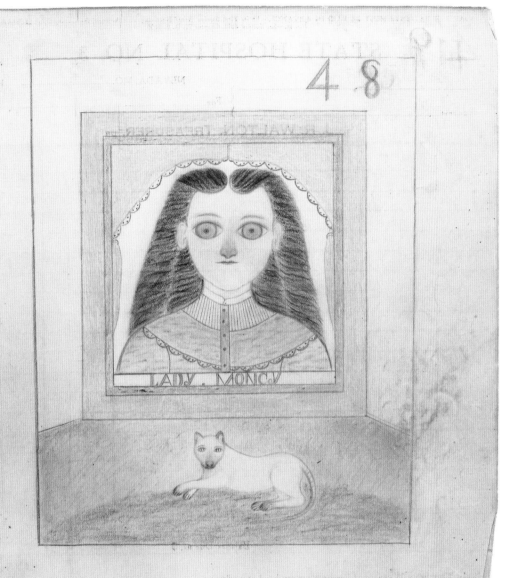

LADY . MONCV

4 9

STATE HOSPITAL NO. 3.

NEVADA, MO.,_____190

Address_____ } For_____

TO J. R. WALTON, TREASURER, DR.

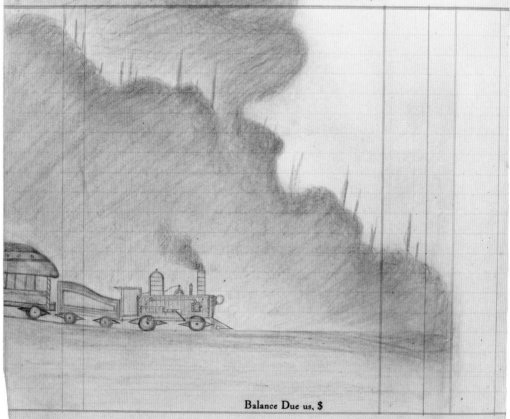

Balance Due us, $

In Testimony Whereof, I hereunto set my hand and affix
my official seal, this_____day of_____190___

Superintendent.

Please Return This Statement When You Remit.

J. R. WALTON, Treasur

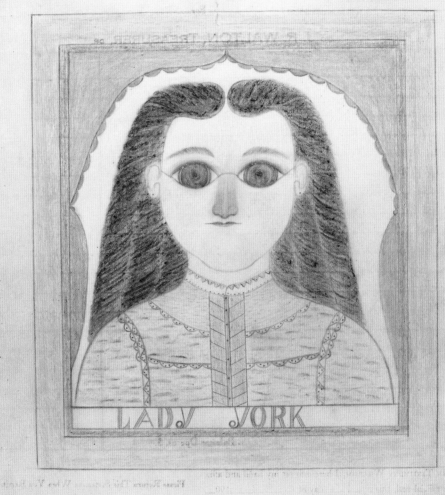

LADY YORK

STATE HOSPITAL NO. 3.

NEVADA, MO.,_____190__

Address _____ } For _____

to J. R. WALTON, Treasurer, dr.

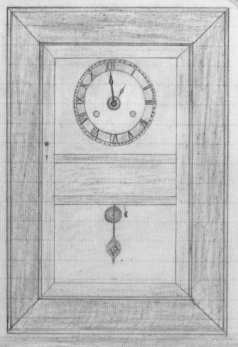

>——<THE FRENCH CLOCK>——<

Balance Due us, $

In Testimony Whereof, I hereunto set my hand and affix my official seal, this_____day of_____190__

..
Superintendent.

Please Return This Statement When You Remit.

J. R. WALTON, Treasurer.

52

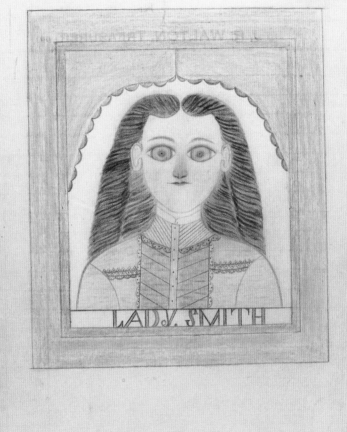

LADY SMITH

STATE HOSPITAL NO. 3.

NEVADA, MO., _____ 190__

Address **53** _____ } For _____

to J. R. WALTON. TREASURER, DR.

Balance Due us, $ _____

In Testimony Whereof, I hereunto set my hand and affix
my official seal, this _____ day of _____ 190___

Superintendent.

Please Return This Statement When You Remit.

J. R. WALTON, Treasurer.

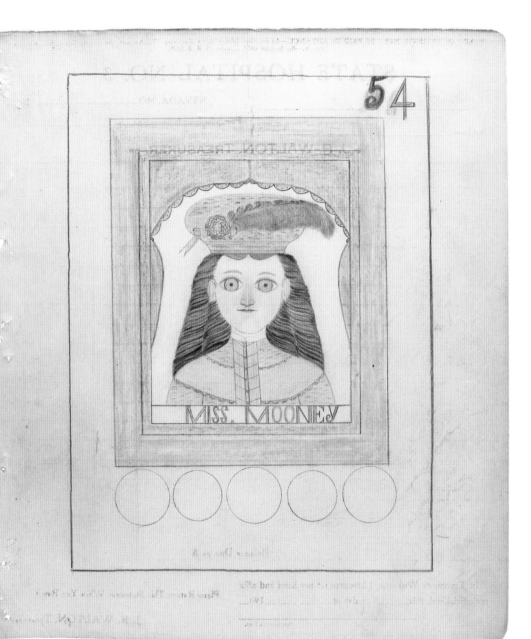

MISS. MOONEY

55 STATE HOSPITAL NO. 3.

NEVADA, MO.,_____190__

Address _____ } For _____

TO J. R. WALTON. TREASURER, DR.

Balance Due us, $

IN TESTIMONY WHEREOF, I hereunto set my hand and affix
my official seal, this_____day of_____190__

Superintendent.

Please Return This Statement When You Remit.

J. R. WALTON, Treasurer.

HOUSE.CAT

WILD CAT

BOOL FROG

57 STATE HOSPITAL NO. 3.

NEVADA, MO.,_____190__

Address_____ } For_____

TO **J. R. WALTON, TREASURER,** DR.

A PORTION OF SOUTH AMERICA

Balance Due us, $

IN TESTIMONY WHEREOF, I hereunto set my hand and affix
my official seal, this_____day of_____190__

Superintendent.

Please Return This Statement When You Remit.

J. R. WALTON, Treasurer.

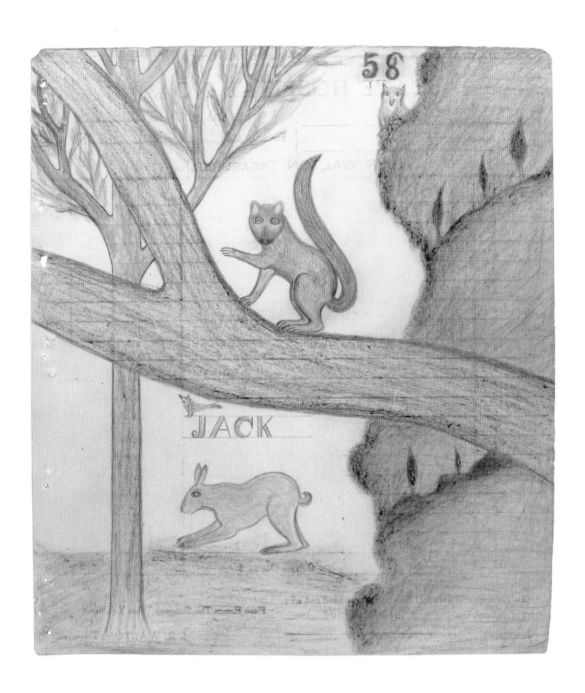

59

STATE HOSPITAL NO. 3.

NEVADA, MO.,_____190___

_____ } For_____

Address_____

TO **J. R. WALTON. TREASURER,** DR.

ROCK. OF AGES

Balance Due us, $_____

IN TESTIMONY WHEREOF, I hereunto set my hand and affix
my official seal, this_____day of_____190____

Superintendent.

Please Return This Statement When You Remit.

J. R. WALTON. Treasurer.

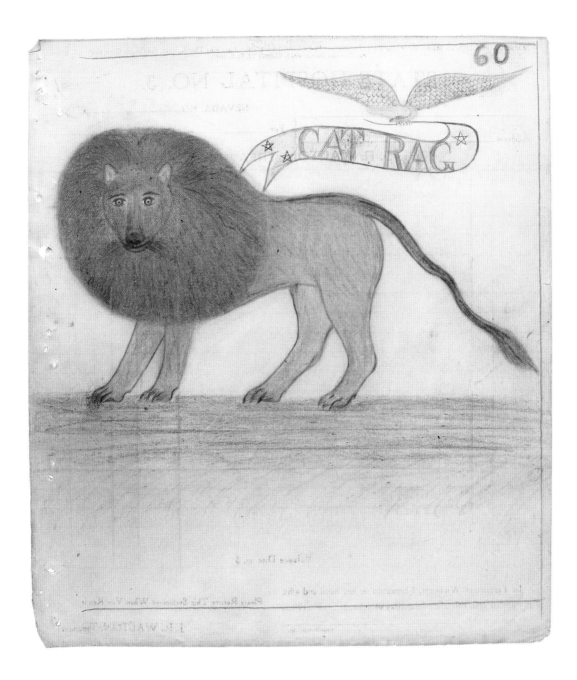

61 STATE HOSPITAL NO. 3.

NEVADA, MO.,_____190__

_____ } For _____

Address_____

TO **J. R. WALTON**, TREASURER, DR.

Balance Due us, $

IN TESTIMONY WHEREOF, I hereunto set my hand and affix
my official seal, this_____day of_____190___

Superintendent.

Please Return This Statement When You Remit.

J. R. WALTON, Treasurer.

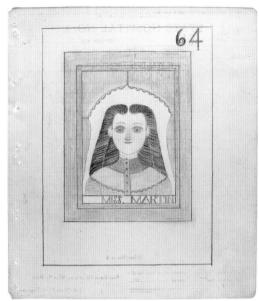

62

TIGER JENT

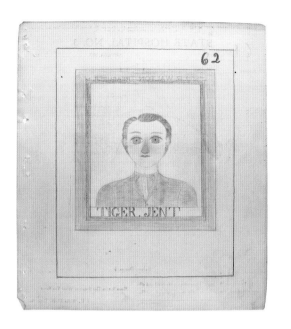

64

MISS MARTIN

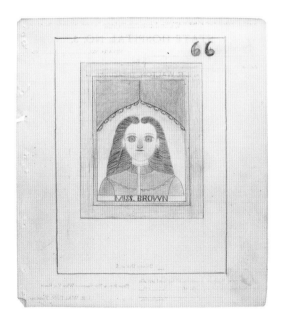

66

MISS BROWN

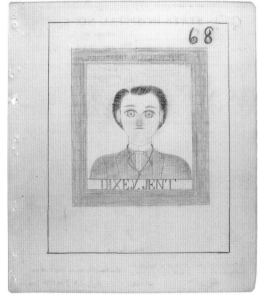

68

DIXE JENT

65 STATE HOSPITAL NO. 3.

NEVADA, MO. _____ 190___

Address _____ } For _____

to **J. R. WALTON, TREASURER,** Dr.

Balance Due us, $ _____

In Testimony Whereof, I hereunto set my hand and affix my official seal, this _____ day of _____ 190___

Superintendent.

Please Return This Statement When You Remit.

J. R. WALTON, Treasurer.

63 STATE HOSPITAL NO. 3.

NEVADA, MO. _____ 190___

Address _____ } For _____

to **J. R. WALTON, TREASURER,** Dr.

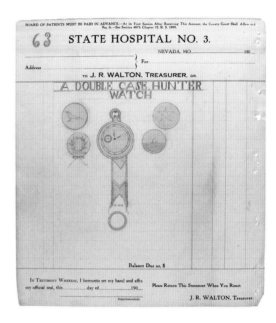

Balance Due us, $ _____

In Testimony Whereof, I hereunto set my hand and affix my official seal, this _____ day of _____ 190___

Superintendent.

Please Return This Statement When You Remit.

J. R. WALTON, Treasurer.

69 STATE HOSPITAL NO. 3.

NEVADA, MO. _____ 190___

Address _____ } For _____

to **J. R. WALTON, TREASURER,** Dr.

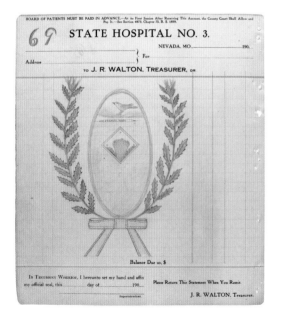

Balance Due us, $ _____

In Testimony Whereof, I hereunto set my hand and affix my official seal, this _____ day of _____ 190___

Superintendent.

Please Return This Statement When You Remit.

J. R. WALTON, Treasurer.

67 STATE HOSPITAL NO. 3.

NEVADA, MO. _____ 190___

Address _____ } For _____

to **J. R. WALTON, TREASURER,** Dr.

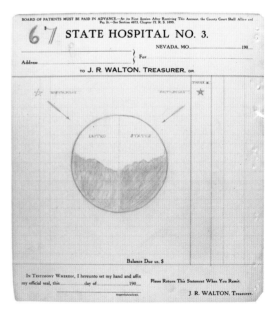

Balance Due us, $ _____

In Testimony Whereof, I hereunto set my hand and affix my official seal, this _____ day of _____ 190___

Superintendent.

Please Return This Statement When You Remit.

J. R. WALTON, Treasurer.

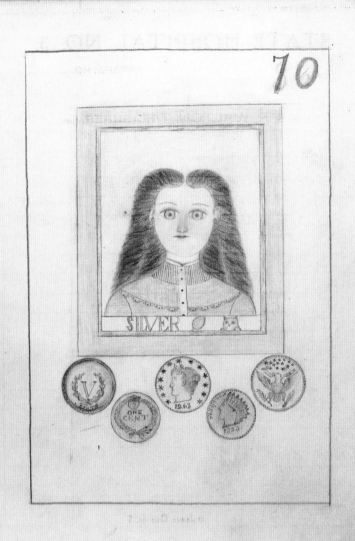

70 STATE HOSPITAL NO. 3.

NEVADA, MO.,_____190__

Address_____ } For_____

TO J. R. WALTON, TREASURER, DR.

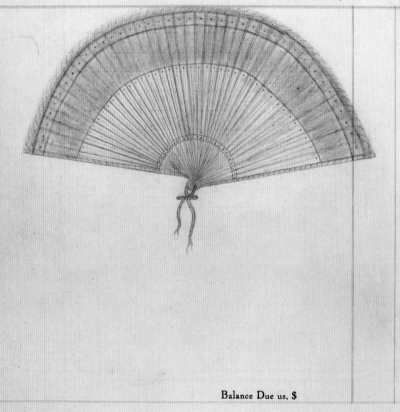

Balance Due us, $

IN TESTIMONY WHEREOF, I hereunto set my hand and affix my official seal, this_____day of_____190____

Superintendent.

Please Return This Statement When You Remit.

J. R. WALTON, Treasurer.

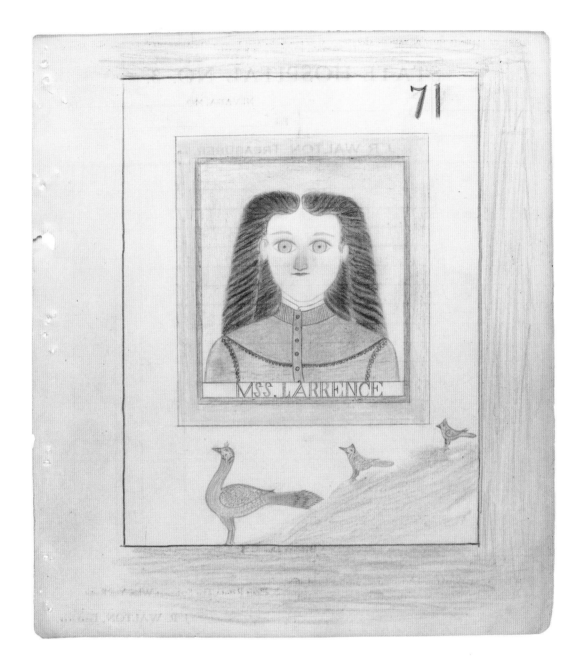

MSS. LARRENCE

72 STATE HOSPITAL NO. 3.

NEVADA, MO.,————————190—

Address————————————————— } For————————————————

TO J. R. WALTON, TREASURER, DR.

WELL SIR TRUMBO

BANJO

Balance Due us, $

IN TESTIMONY WHEREOF, I hereunto set my hand and affix my official seal, this————day of————190—

————————————————
Superintendent.

Please Return This Statement When You Remit.

J. R. WALTON, Treasurer.

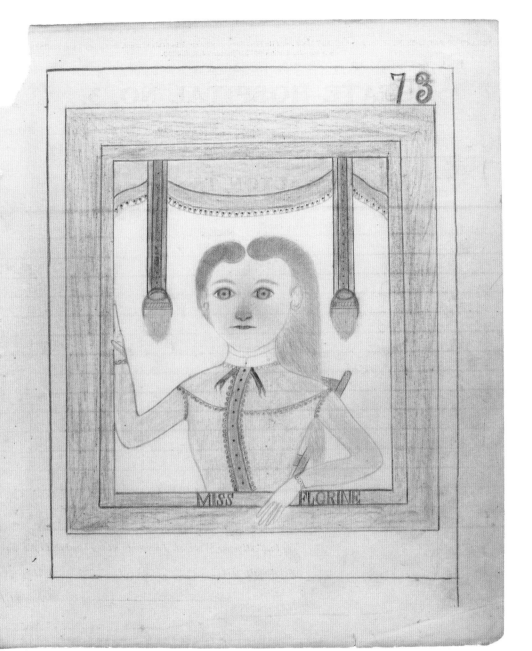

MISS FLORINE

74

STATE HOSPITAL NO. 3.

Nevada, Mo., _____ 190___

for_____

TO **J. R. WALTON, Treasurer,** DR.

Balance Due us $

In Testimony Whereof, I hereunto set my hand and affix my

official seal, this_____day of_____190___

_____ Superintendent.

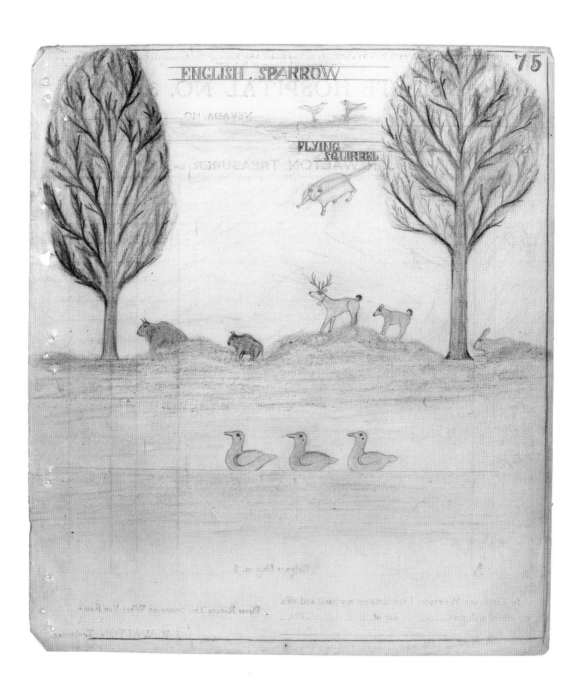

ENGLISH SPARROW

FLYING SQUIRREL

76

STATE HOSPITAL NO. 3.

NEVADA, MO.,_____190__

Address _____ } For _____

TO J. R. WALTON. TREASURER, DR.

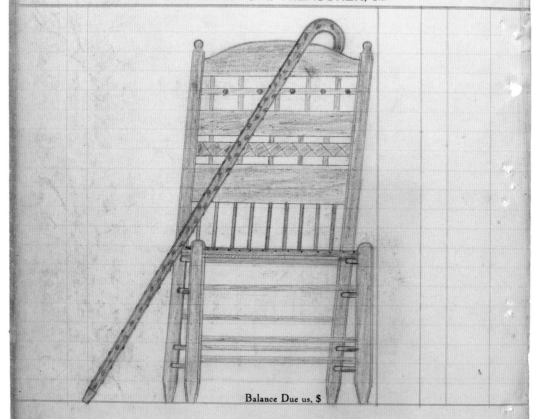

Balance Due us, $_____

IN TESTIMONY WHEREOF, I hereunto set my hand and affix my official seal, this_____day of_____190___

Superintendent.

Please Return This Statement When You Remit.

J. R. WALTON, Treasurer.

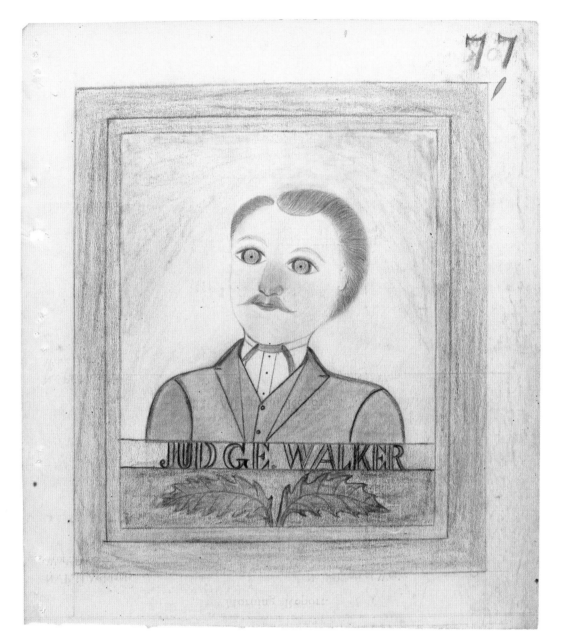

JUDGE WALKER

Morning Report.

No. Paid Assistants_____ No. Patients at Work_____
Work Done:--

Afternoon Report.

No. Paid Assistants_____ No. Patients at Work_____
Work Done:—

General Remarks:--

 Head of Dept.

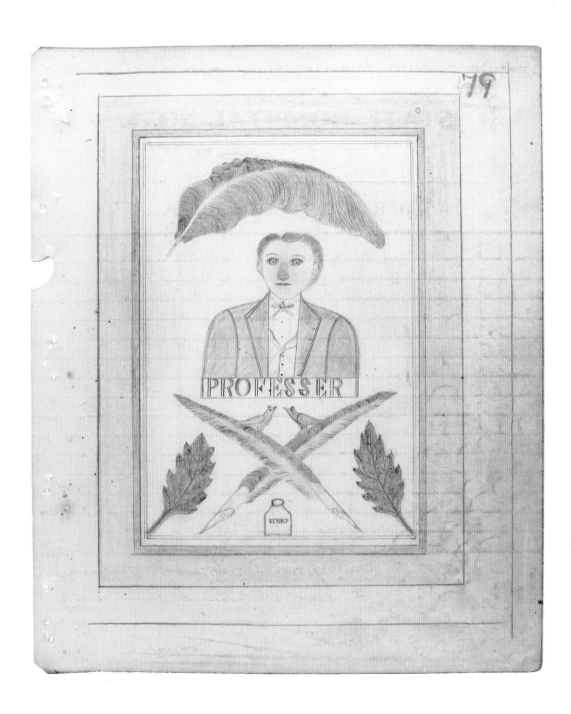

PROFESSER

80 STATE HOSPITAL NO. 3.

Nevada, Mo., _____ 190____

for _____

TO **J. R. WALTON**, Treasurer, DR.

PRICE $ 30

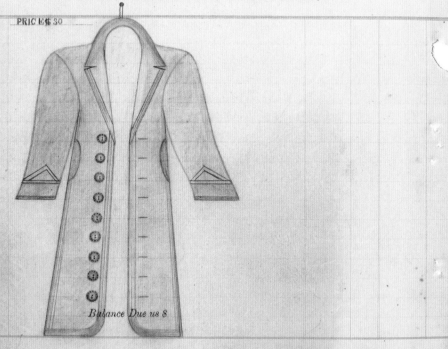

Balance Due us $

In Testimony Whereof, I hereunto set my hand and affix my

_official seal, this_____day of_____190____

_____ _Superintendent:_

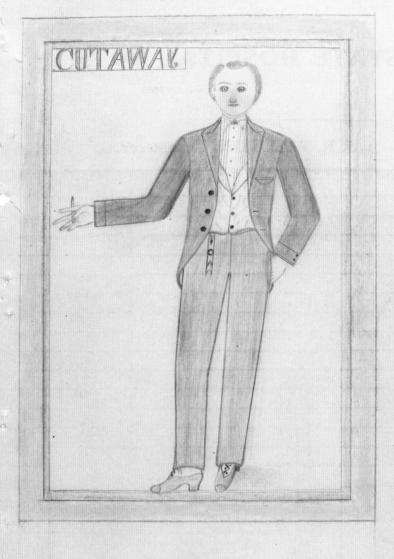

CUTAWAY

81

82

STATE HOSPITAL NO. 3.

Nevada, Mo., _____ 190___

.........for.........

HATS AND CAPS

TO **J. R. WALTON, Treasurer,** DR.

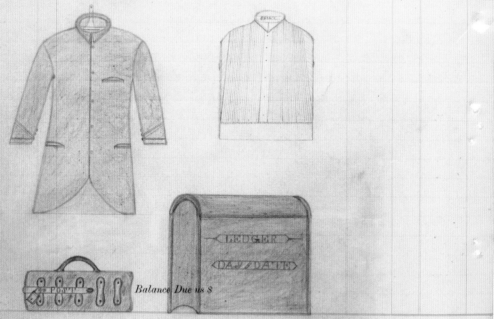

Balance Due us $ _____

In Testimony Whereof, I hereunto set my hand and affix my

official seal, this_____day of_____190___

_____ Superintendent.

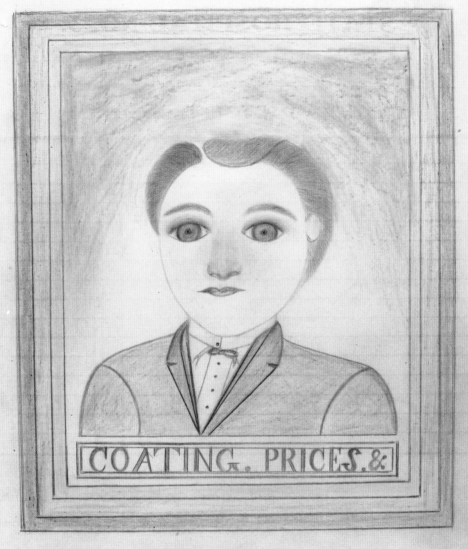

83

COATING. PRICES. &

84STATE HOSPITAL NO. 3.

Nevada, Mo., 190

for

TO **J. R. WALTON, Treasurer,** DR.

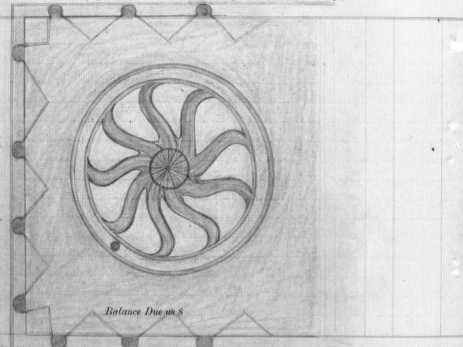

Balance Due us $

In Testimony Whereof, I hereunto set my hand and affix my

official seal, this day of 190

Superintendent.

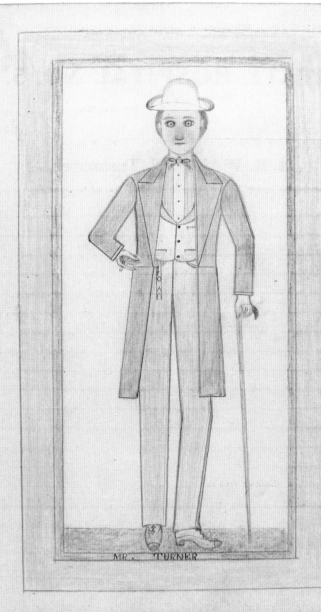

MR. TURNER

STATE HOSPITAL NO. 3.

Nevada, Mo., _____ 190____

_____for_____

TO **J. R. WALTON, Treasurer,** DR.

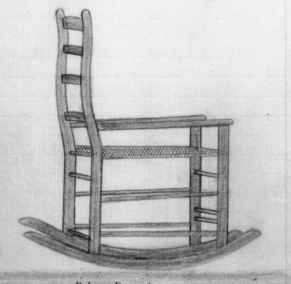

Balance Due us $

_In Testimony Whereof, I hereunto set my hand and affix my official seal, this_____day of_____190____

_____ _Superintendent:_

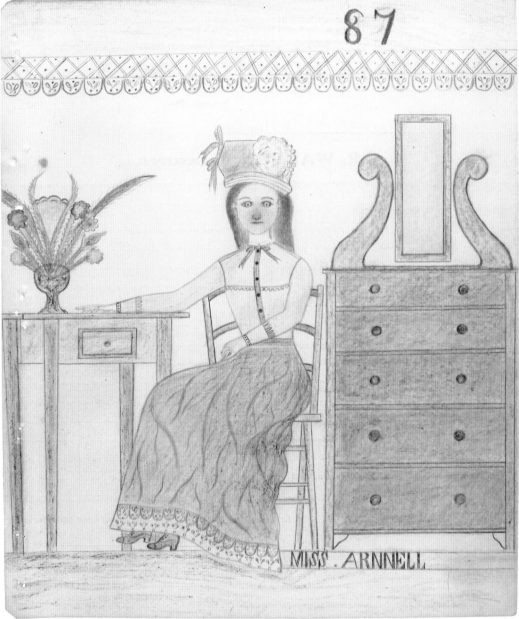

87

MISS. ARNNELL

88

STATE HOSPITAL NO. 3.

Nevada, Mo., 190....

for ...

TO **J. R. WALTON, Treasurer,** DR.

Balance Due us $

In Testimony Whereof, I hereunto set my hand and affix my

official seal, this........................*day of*.......................*190....*

...*Superintendent.*

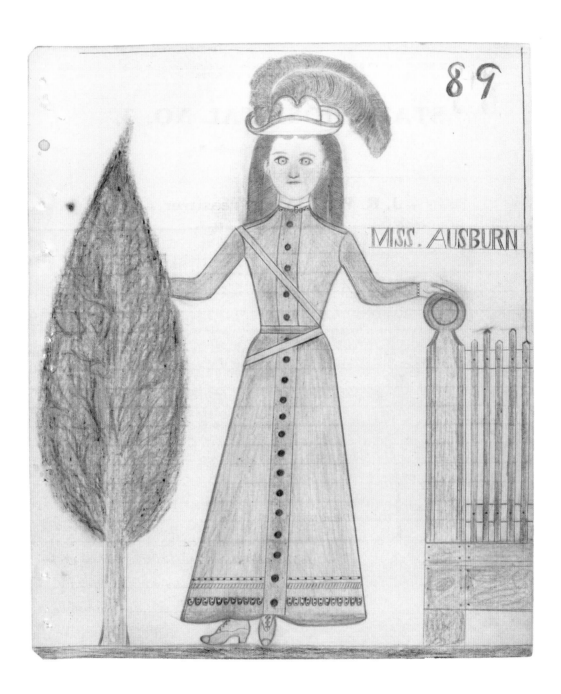

90 STATE HOSPITAL NO. 3.

Nevada, Mo., _____ 190____

_____ for _____

TO **J. R. WALTON, Treasurer,** DR.

BIG. G

Balance Due us $

_In Testimony Whereof, I hereunto set my hand and affix my official seal, this _____ day of _____ 190____

_____ Superintendent._

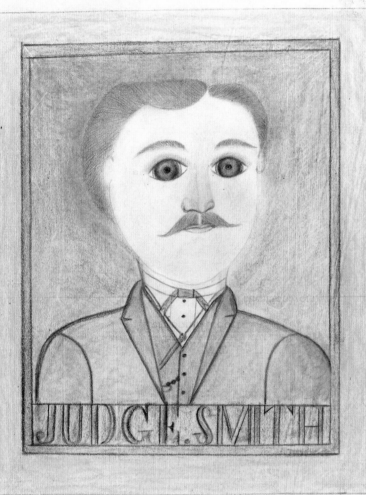

91

General Remarks:--

No. Paid Assistants
Work Done:--

Afternoon Report.

No. Patients at Work

No. Paid Assistants
_Work Done:--

Morning Report.

No. Paid Assistants

No. Patients at Work

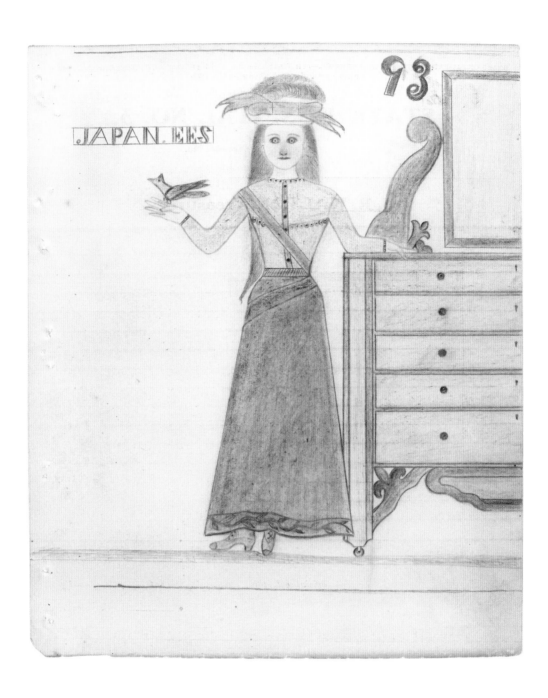

JAPAN. EES

93

STATE HOSPITAL NO. 3.

Nevada, Mo., _____ 190___

for _____

TO J. R. WALTON, Treasurer, DR.

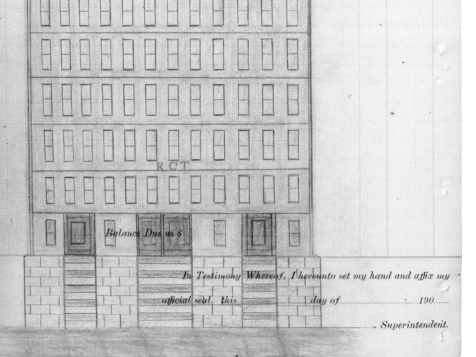

Balance Due us $

_In Testimony Whereof, I hereunto set my hand and affix my official seal, this _____ day of _____ 190___._

_____, Superintendent._

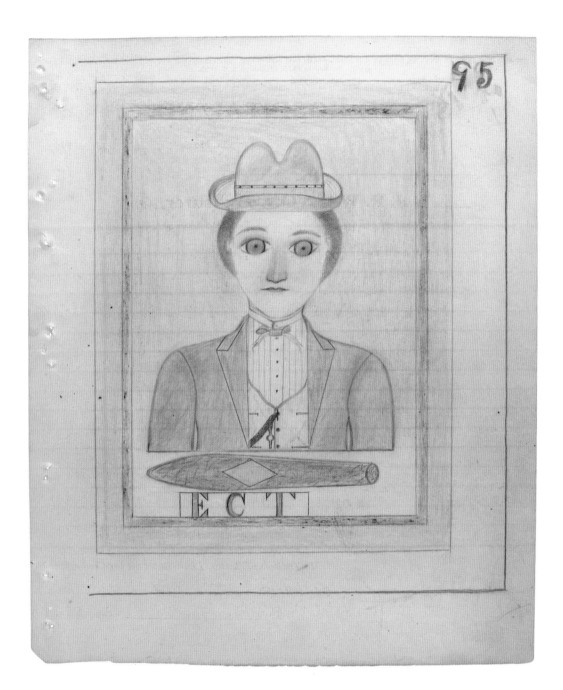

96

STATE HOSPITAL NO. 3.

Nevada, Mo., _____ 190___

_____ for _____

TO **J. R. WALTON, Treasurer,** DR.

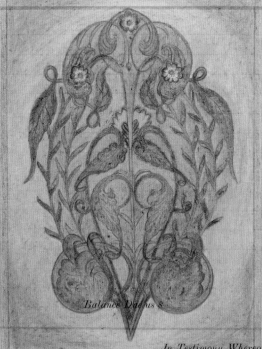

Balance Due as $

In Testimony Whereof, I hereunto set my hand and affix my

official seal, this _____ day of _____ 190___

_____ Superintendent.

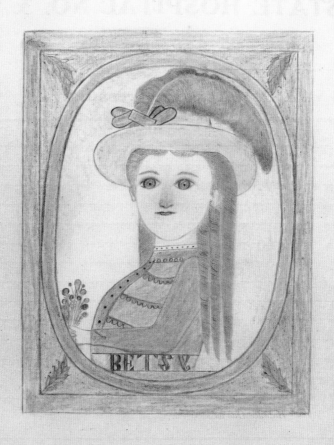

BETSY

STATE HOSPITAL NO. 3.

Nevada, Mo., _____ 190____

_____ for _____

TO **J. R. WALTON, Treasurer,** DR.

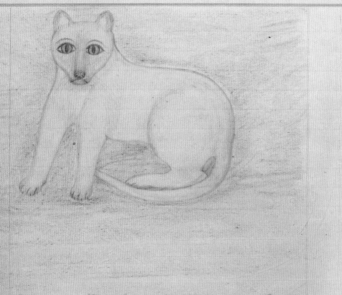

Balance Due us $ _____

In Testimony Whereof, I hereunto set my hand and affix my

_official seal, this _____ day of _____ 190____

_____ Superintendent

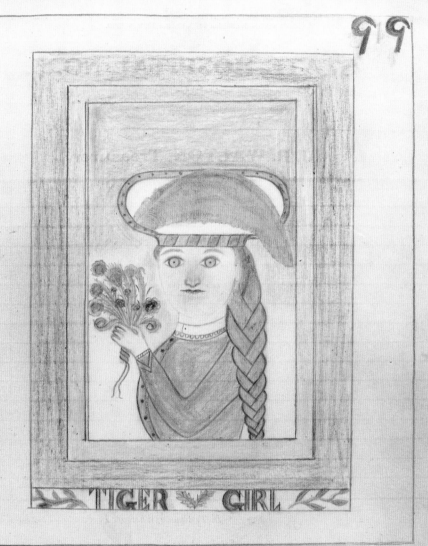

TIGER GIRL

100

STATE HOSPITAL NO. 3.

Nevada, Mo., 190....

................for................

TO **J. R. WALTON, Treasurer,** DR.

Balance Due us $..............

In Testimony Whereof, I hereunto set my hand and affix my

official seal, this.................................day of.........................190....

.. *Superintendent.*

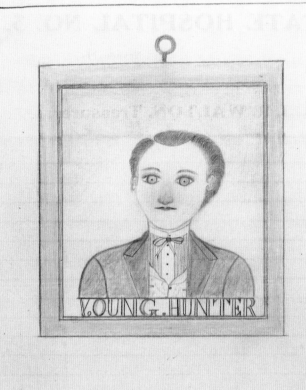

YOUNG. HUNTER

102 STATE HOSPITAL NO. 3.

Nevada, Mo., _____, 190___

_____for_____

To **J. R. WALTON, Treasurer,** DR.

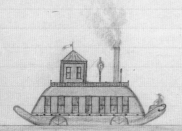

_Balance Due us $_____

In Testimony Whereof, I hereunto set my hand and affix my

_official seal, this_____day of_____, 190___

_____ _Superintendent._

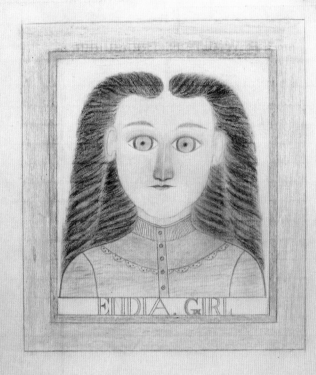

ELDIA. GIRL

104 STATE HOSPITAL NO. 3.

NEVADA, MO.._____190___

Address_____ } For _____

TO J. R. WALTON. TREASURER, DR.

Balance Due us, $ _____

IN TESTIMONY WHEREOF, I hereunto set my hand and affix my official seal, this_____day of_____190___

Please Return This Statement When You Remit.

Superintendent,

J. R. WALTON. Treasurer.

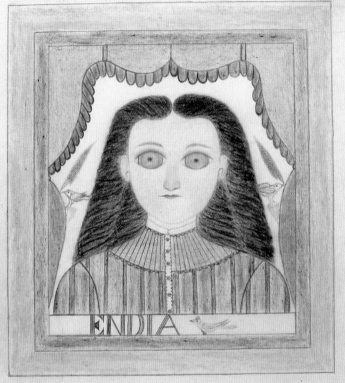

ENDIA

106 STATE HOSPITAL NO. 3.

NEVADA, MO., _____ 190__

Address _____ } For _____

TO J. R. WALTON, TREASURER, DR.

Balance Due us, $ _____

IN TESTIMONY WHEREOF, I hereunto set my hand and affix my official seal, this _____ day of _____ 190__

Please Return This Statement When You Remit.

Superintendent.

J. R. WALTON, Treasurer.

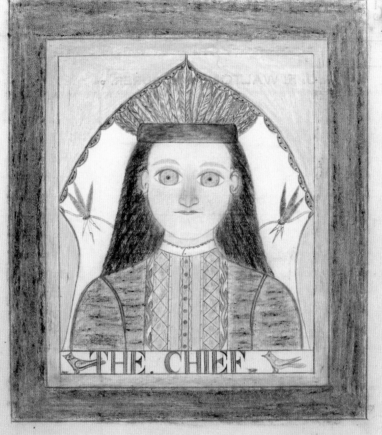

THE. CHIEF.

108 STATE HOSPITAL NO. 3.

NEVADA, MO., _____ 190___

Address _____ } For _____

TO J. R. WALTON, TREASURER, DR.

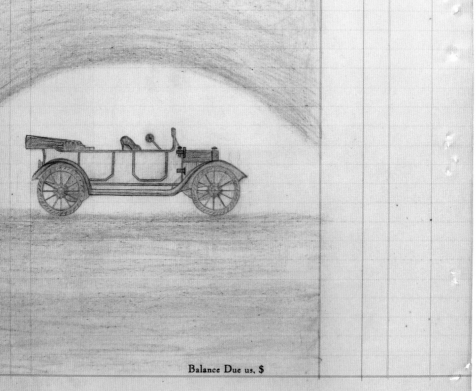

Balance Due us, $ _____

IN TESTIMONY WHEREOF, I hereunto set my hand and affix my official seal, this _____ day of _____ 190___

Superintendent.

Please Return This Statement When You Remit.

J. R. WALTON, Treasurer.

PADEV

110 STATE HOSPITAL NO. 3.

NEVADA, MO.,_____190___

TRANSPORT }For_____

Address_____

TO J. R. WALTON, TREASURER, DR.

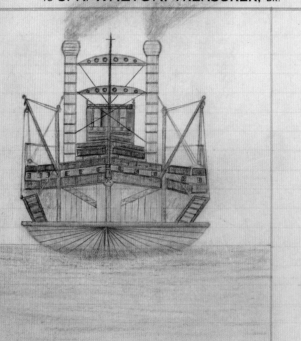

Balance Due us, $

In TESTIMONY WHEREOF, I hereunto set my hand and affix my official seal, this_____day of_____190___

Please Return This Statement When You Remit.

Superintendent.

J. R. WALTON, Treasurer.

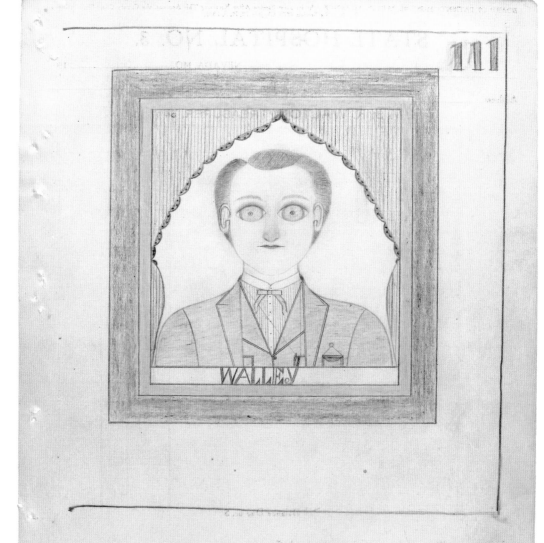

WALLEV

111

STATE HOSPITAL NO. 3.

112

NEVADA, MO.,_____190__

Address_____ } For_____

TO **J. R. WALTON, TREASURER,** DR.

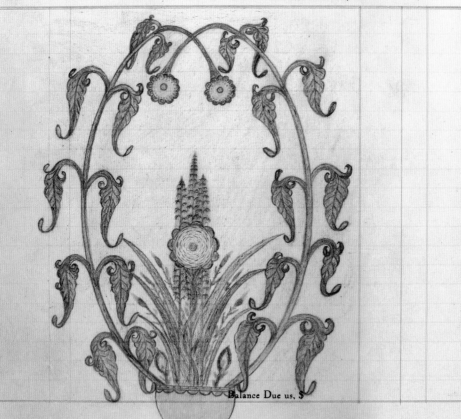

Balance Due us, $_____

In Testimony Whereof, I hereunto set my hand and affix my official seal, this_____day of_____190__

Please Return This Statement When You Remit.

Superintendent.

J. R. WALTON, Treasurer.

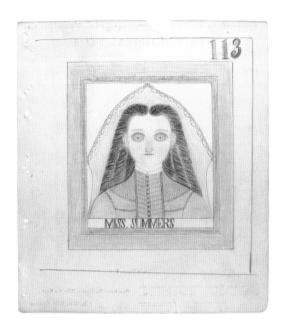

113

MISS. SUMMERS

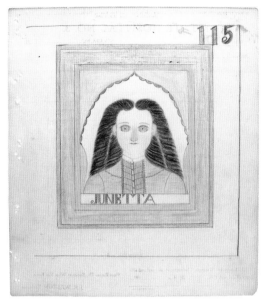

115

JUNETTA

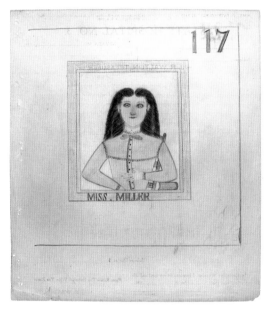

117

MISS. MILLER

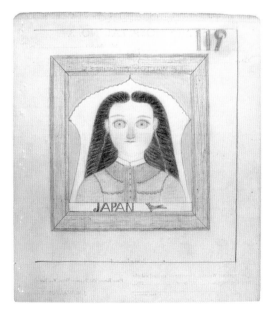

119

JAPAN

116 STATE HOSPITAL NO. 3.

NEVADA, MO..................190....

Address................{ For................

to J. R. WALTON, Treasurer, dr.

Balance Due us, $

In Testimony Whereof, I hereunto set my hand and affix
my official seal, this.........day of...........190....

Please Return This Statement When You Remit

Superintendent.

J. R. WALTON, Treasurer.

114 STATE HOSPITAL NO. 3.

NEVADA, MO..................190....

Address................{ For................

to J. R. WALTON, Treasurer, dr.

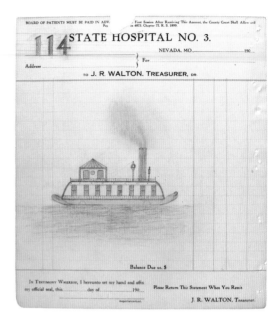

Balance Due us, $

In Testimony Whereof, I hereunto set my hand and affix
my official seal, this.........day of...........190....

Please Return This Statement When You Remit

Superintendent.

J. R. WALTON, Treasurer.

120 STATE HOSPITAL NO. 3.

NEVADA, MO..................190....

Address................{ For................

to J. R. WALTON, Treasurer, dr.

NEVADA SWAMP LILLEY

Balance Due us, $

In Testimony Whereof, I hereunto set my hand and affix
my official seal, this.........day of...........190....

Please Return This Statement When You Remit

Superintendent.

J. R. WALTON, Treasurer.

118 STATE HOSPITAL NO. 3.

NEVADA, MO..................190....

Address................{ For................

to J. R. WALTON, Treasurer, dr.

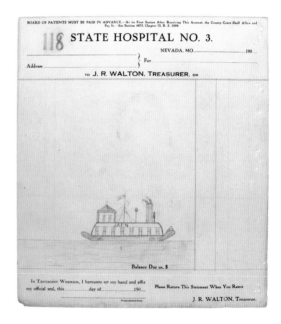

Balance Due us, $

In Testimony Whereof, I hereunto set my hand and affix
my official seal, this.........day of...........190....

Please Return This Statement When You Remit

Superintendent.

J. R. WALTON, Treasurer.

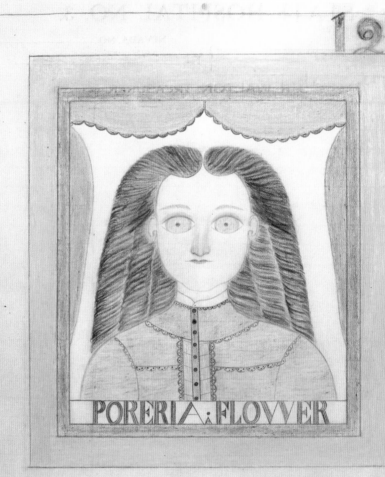

PORERIA FLOWWER

STATE HOSPITAL NO. 3.

122

NEVADA, MO., _____ 190

Address _____ } For _____

TO J. R. WALTON. TREASURER, DR.

Balance Due us, $

IN TESTIMONY WHEREOF, I hereunto set my hand and affix
my official seal, this _____ day of _____ 190____

Superintendent.

Please Return This Statement When You Remit.

J. R. WALTON, Treasurer.

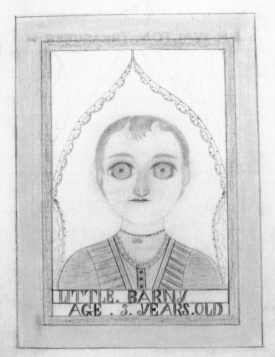

LITTLE. BARNV
AGE . 3. YEARS. OLD

124 STATE HOSPITAL NO. 3.

NEVADA, MO.,_____190__

Address_____ } For_____

TO J. R. WALTON, TREASURER, DR.

Balance Due us, $

In TESTIMONY WHEREOF, I hereunto set my hand and affix my official seal, this_____day of_____190___

Superintendent.

Please Return This Statement When You Remit.

J. R. WALTON, Treasurer.

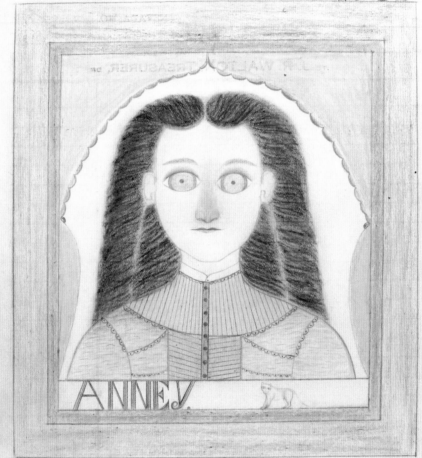

ANNE

STATE HOSPITAL NO. 3.

NEVADA, MO., _____ 190__

Address **126** } For _____

TO J. R. WALTON, TREASURER, DR.

Balance Due us, $ _____

IN TESTIMONY WHEREOF, I hereunto set my hand and affix
my official seal, this_____ day of_____ 190__

Superintendent.

Please Return This Statement When You Remit.

J. R. WALTON, Treasurer.

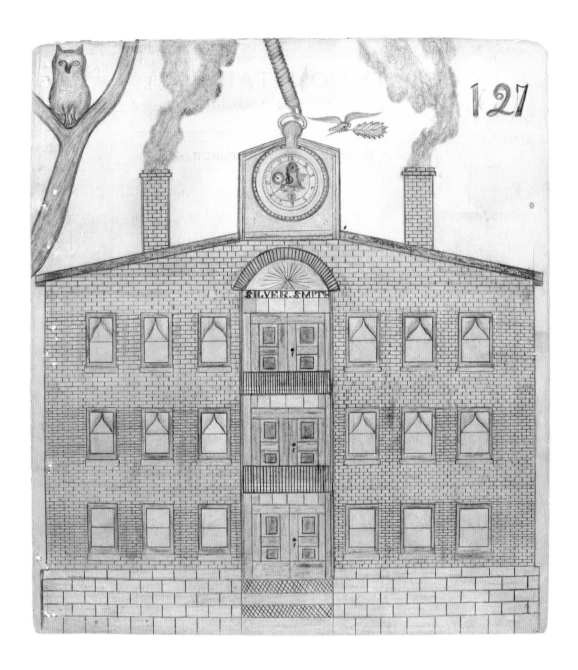

STATE HOSPITAL NO. 3.

NEVADA, MO.,_____,190__

Address _____ **128** _____ } For_____

TO J. R. WALTON. TREASURER, DR.

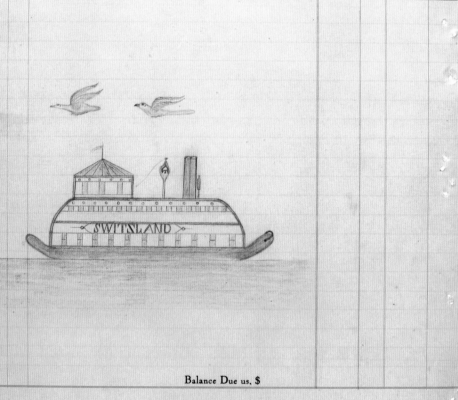

Balance Due us, $

IN TESTIMONY WHEREOF, I hereunto set my hand and affix my official seal, this_____day of_____190____

Superintendent.

Please Return This Statement When You Remit.

J. R. WALTON, Treasurer.

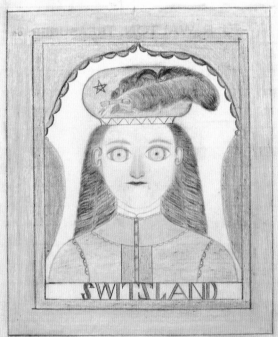

SWITSLAND

STATE HOSPITAL NO. 3.

NEVADA, MO.,_____190___

Address __130__ } For_____

TO **J. R. WALTON, TREASURER,** DR.

MOSTLY IN SOUTH AMERICA

Balance Due us, $

IN TESTIMONY WHEREOF, I hereunto set my hand and affix
my official seal, this_____day of_____190____

Superintendent.

Please Return This Statement When You Remit.

J. R. WALTON, Treasurer.

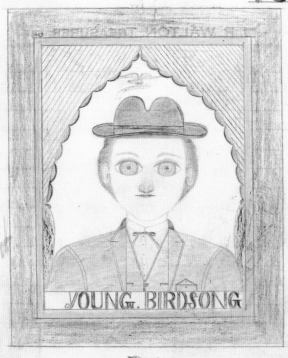

YOUNG. BIRDSONG

STATE HOSPITAL NO. 3.

132

NEVADA, MO.,_____ 190_

Address_____ } For_____

TO **J. R. WALTON. TREASURER,** DR.

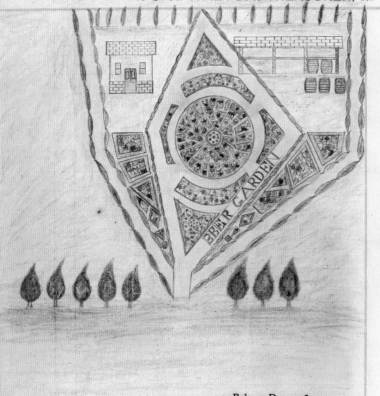

BEER GARDEN

Balance Due us, $_____

IN TESTIMONY WHEREOF, I hereunto set my hand and affix my official seal, this_____day of_____190___

Superintendent.

Please Return This Statement When You Remit.

J. R. WALTON, Treasurer.

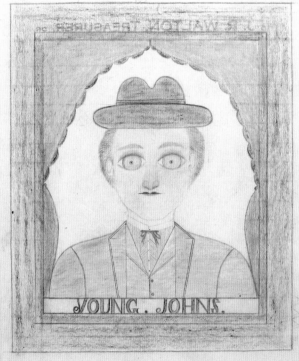

YOUNG. JOHNS.

STATE HOSPITAL NO. 3.

134

NEVADA, MO., _____ 190__

For _____

Address _____

TO **J. R. WALTON, TREASURER,** DR.

Balance Due us, $ _____

IN TESTIMONY WHEREOF, I hereunto set my hand and affix my official seal, this _____ day of _____ 190__

Please Return This Statement When You Remit.

Superintendent.

J. R. WALTON, Treasurer.

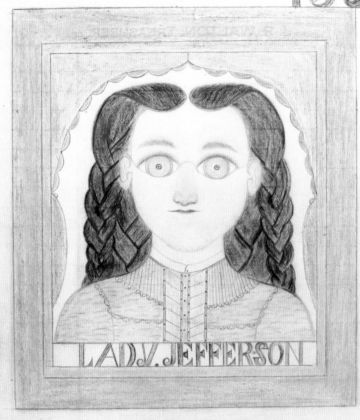

LADY JEFFERSON

STATE HOSPITAL NO. 3.

136

NEVADA, MO.,_____190__

Address_____ } For_____

TO J. R. WALTON. TREASURER, DR.

Balance Due us, $

In Testimony Whereof, I hereunto set my hand and affix my official seal, this_____day of_____190__

Please Return This Statement When You Remit.

Superintendent.

J. R. WALTON, Treasurer.

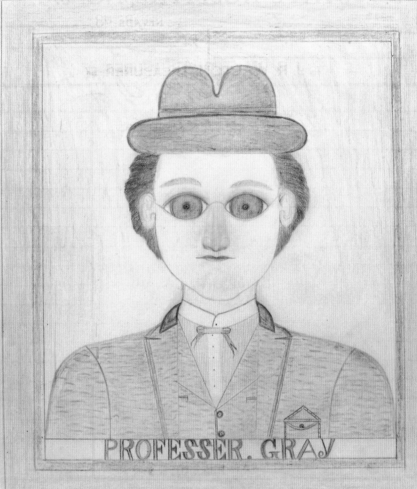

PROFESSER. GRAY

STATE HOSPITAL NO. 3.

138

NEVADA, MO.,_____190__

Address_____ } For_____

TO **J. R. WALTON. Treasurer,** DR.

Balance Due us, $

IN TESTIMONY WHEREOF, I hereunto set my hand and affix my official seal, this_____day of_____190___

Superintendent.

Please Return This Statement When You Remit.

J. R. WALTON, Treasurer.

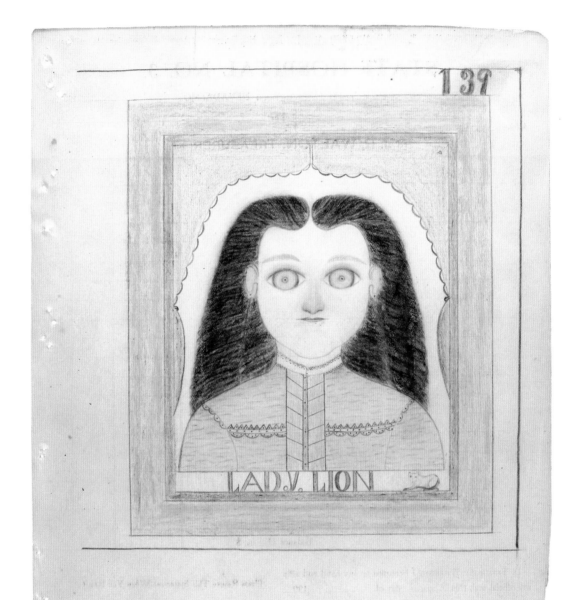

LADY LION

(140)

STATE HOSPITAL NO. 3.

NEVADA, MO.,_____190___

_____ } For_____

Address _____

TO J. R. WALTON, TREASURER, DR.

CONFECTIONARY

SUGAR

O FOR A THOUSAND TONGUES

Balance Due us, $_____

IN TESTIMONY WHEREOF, I hereunto set my hand and affix my official seal, this_____day of_____190___

Please Return This Statement When You Remit.

Superintendent.

J. R. WALTON, Treasurer.

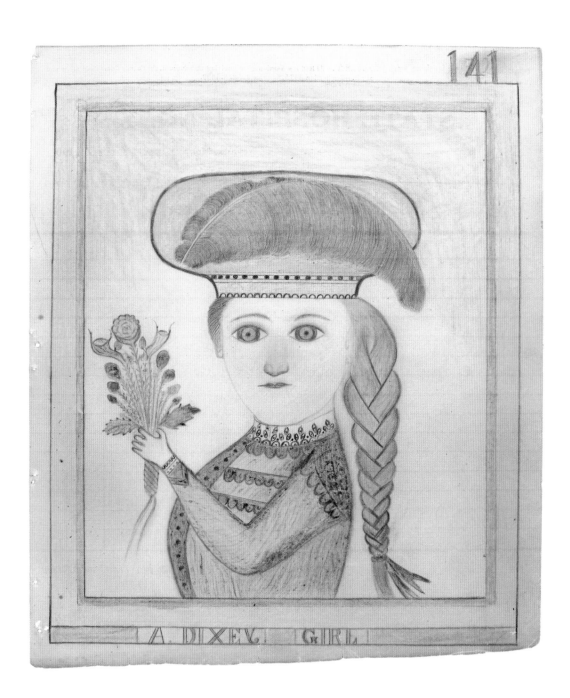

A DIXEY GIRL

STATE HOSPITAL NO. 3.

142

Nevada, Mo., _____ 190___

_____ for _____

TO **J. R. WALTON, Treasurer,** DR.

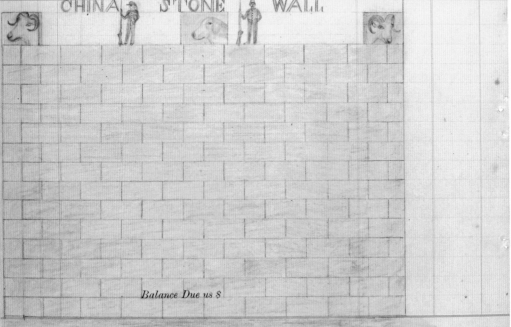

CHINA STONE WALL

Balance Due us $

In Testimony Whereof, I hereunto set my hand and affix my

official seal, this _____ *day of* _____ *190___*

_____ *Superintendent.*

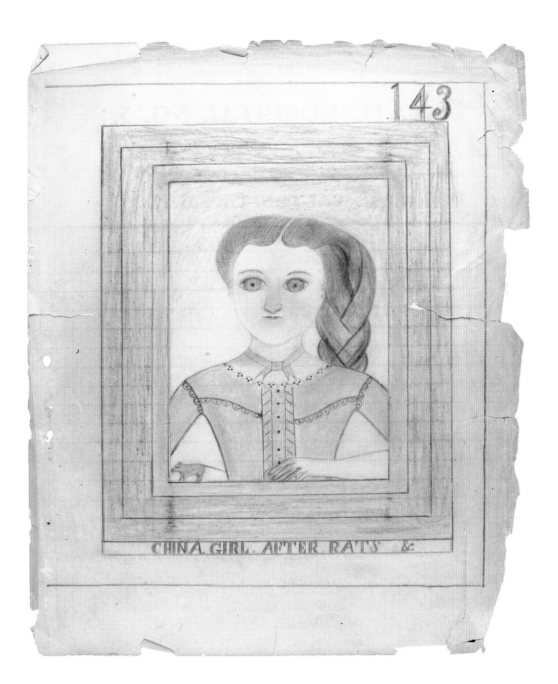

CHINA. GIRL. AFTER. RATS. &

143

STATE HOSPITAL NO. 3.

144

Nevada, Mo., _____ 190___

for _____

TO **J. R. WALTON, Treasurer,** DR.

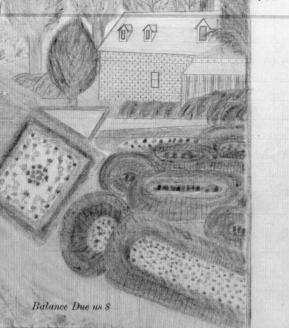

Balance Due us $_____

In Testimony Whereof, I hereunto set my hand and affix my

official seal, this_____ day of_____ 190___

_____ Superintendent.

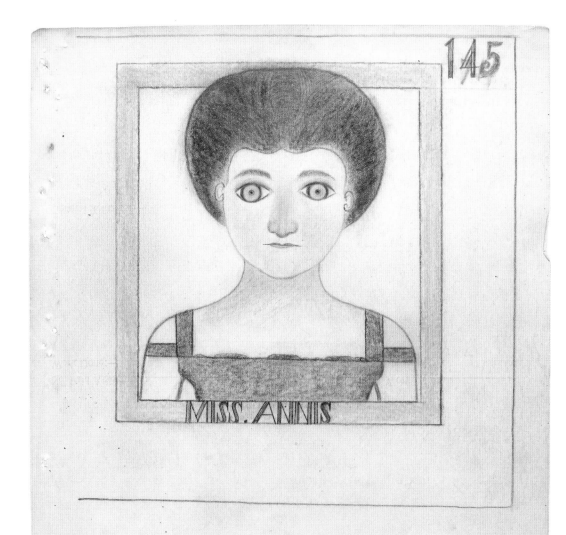

MISS. ANNIS

Work Done:--

Afternoon Report.

No. Paid Assistants_____ No. Patients at Work_____

Work Done:--

General Remarks:--

Head of Dept.

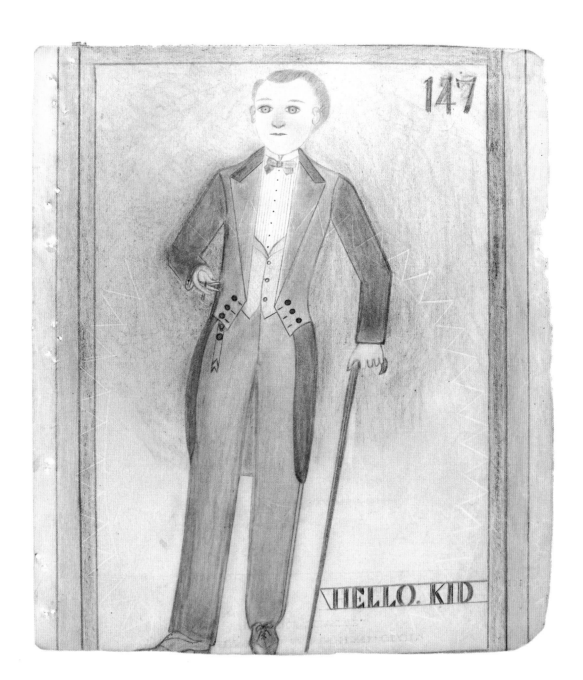

148

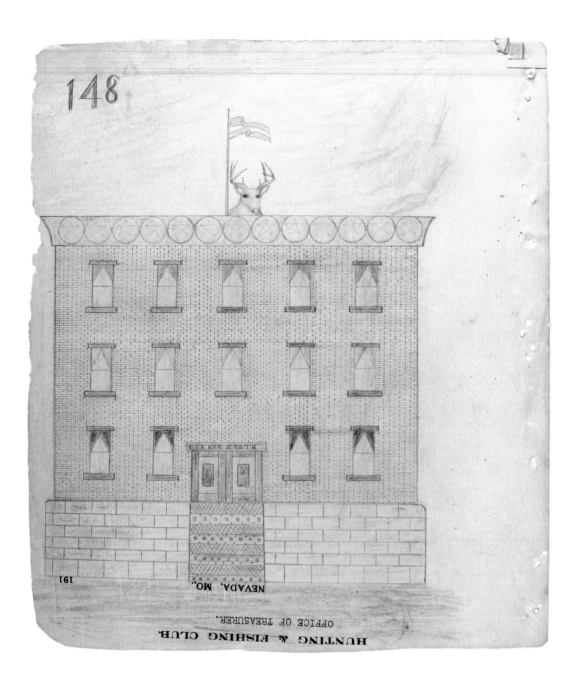

BUCK EYE STATE

HUNTING & FISHING CLUB.
OFFICE OF TREASURER.
NEVADA, MO.

191

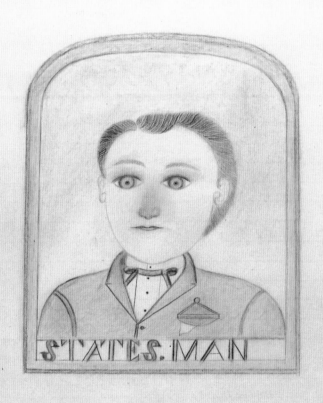

STATES. MAN

150 STATE HOSPITAL NO. 3.

Nevada, Mo., _____ 190__

_____ for _____

TO **J. R. WALTON, Treasurer,** DR.

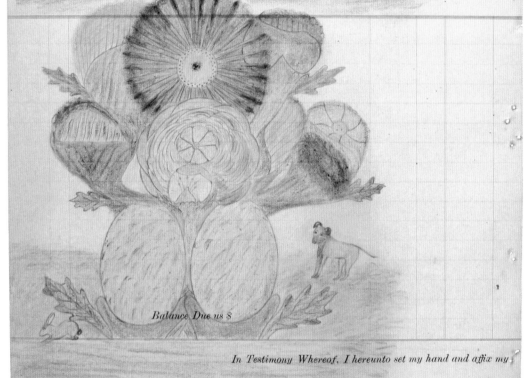

Balance Due us $

In Testimony Whereof, I hereunto set my hand and affix my

official seal, this _____ day of _____ 190__

_____ Superintendent.

151

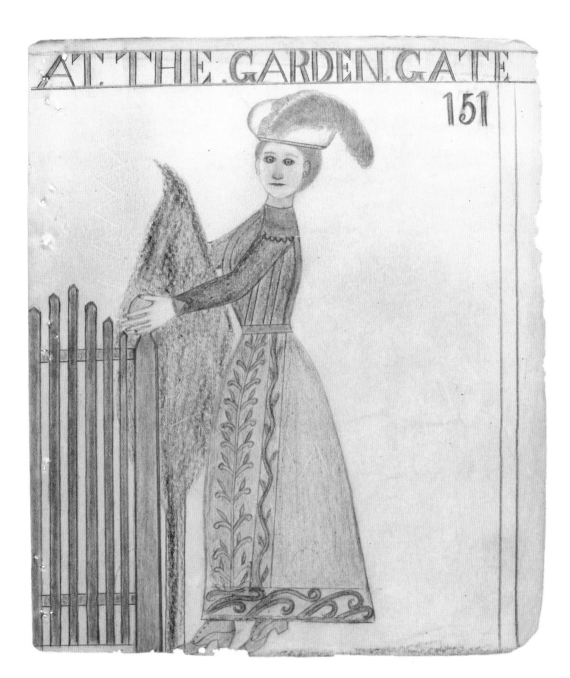

152

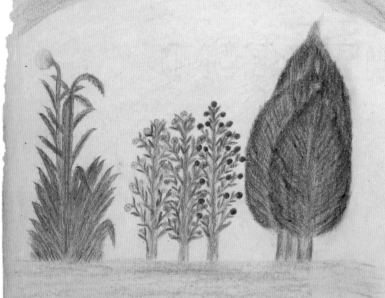

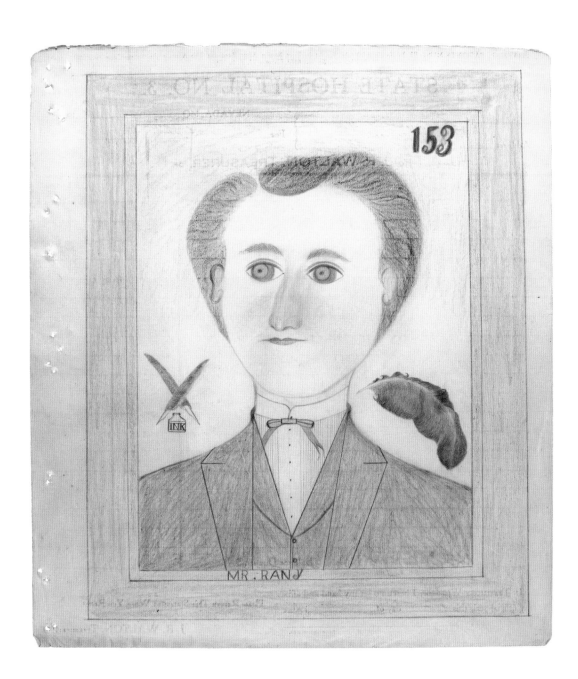

154 STATE HOSPITAL NO. 3.

NEVADA, MO.,_____ 190___

Address_____ } For_____

TO **J. R. WALTON, TREASURER,** DR.

Balance Due us, $_____

IN TESTIMONY WHEREOF, I hereunto set my hand and affix my official seal, this_____ day of_____ 190___

Superintendent.

Please Return This Statement When You Remit.

J. R. WALTON, Treasurer.

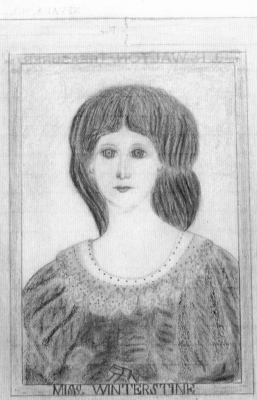

MISS. WINTERSTINE

STATE HOSPITAL NO. 3.

156 ☆

NEVADA, MO.,_____190__

Address _____ } For _____

TO **J. R. WALTON. TREASURER,** DR.

Balance Due us. $

IN TESTIMONY WHEREOF, I hereunto set my hand and affix

my official seal, this_____day of_____190____

Superintendent.

Please Return This Statement When You Remit.

J. R. WALTON. Treasurer.

157

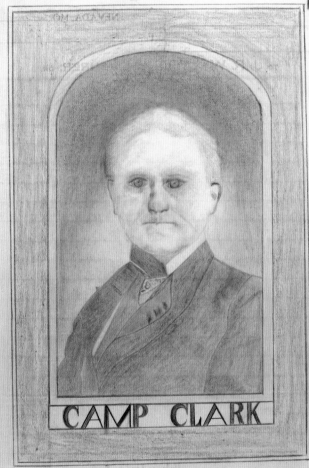

CAMP CLARK

STATE HOSPITAL NO. 3.

158

NEVADA, MO.,_____190___

For_____

Address_____

TO J. R. WALTON, TREASURER, DR.

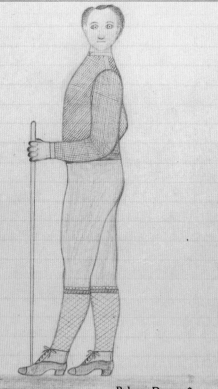

Balance Due us, $

IN TESTIMONY WHEREOF, I hereunto set my hand and affix my official seal, this_____day of_____190___

Superintendent.

Please Return This Statement When You Remit.

J. R. WALTON, Treasurer.

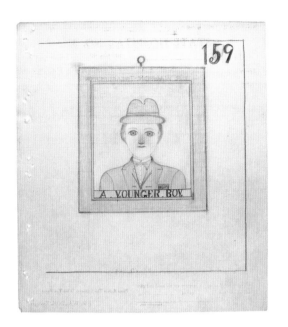

159

A. YOUNGER. BOY.

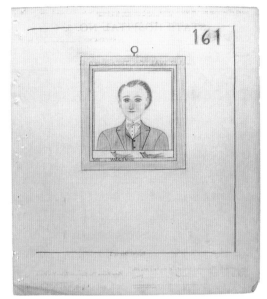

161

MR. WAGINER

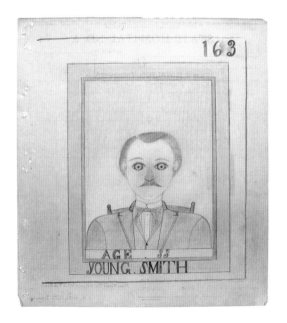

163

AGE . 33
YOUNG. SMITH

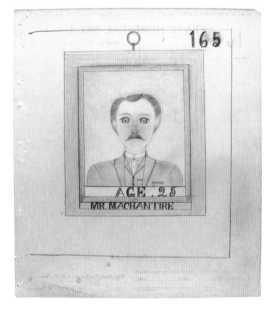

165

AGE . 25
MR. MACHANTIRE

STATE HOSPITAL NO. 3.

162

NEVADA, MO..............190...

Address..............} For..............

to J. R. WALTON, Treasurer, dr.

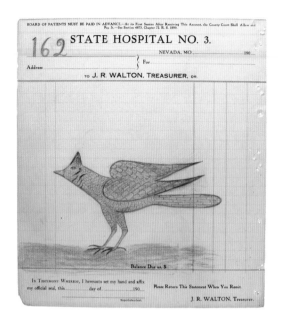

Balance Due us, $..............

In Testimony Whereof, I hereunto set my hand and affix my official seal, this..........day of..........190...

Superintendent.

Please Return This Statement When You Remit.

J. R. WALTON, Treasurer.

STATE HOSPITAL NO. 3.

160

NEVADA, MO..............190...

Address..............} For..............

to J. R. WALTON, Treasurer, dr.

MR. WAGONER'S DOG

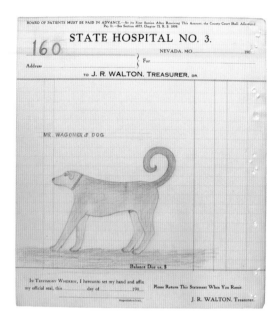

Balance Due us, $..............

In Testimony Whereof, I hereunto set my hand and affix my official seal, this..........day of..........190...

Superintendent.

Please Return This Statement When You Remit.

J. R. WALTON, Treasurer.

STATE HOSPITAL NO. 3.

166

NEVADA, MO..............190...

Address..............} For..............

to J. R. WALTON, Treasurer, dr.

Balance Due us, $..............

In Testimony Whereof, I hereunto set my hand and affix my official seal, this..........day of..........190...

Superintendent.

Please Return This Statement When You Remit.

J. R. WALTON, Treasurer.

STATE HOSPITAL NO. 3.

164

NEVADA, MO..............190...

Address..............} For..............

to J. R. WALTON, Treasurer, dr.

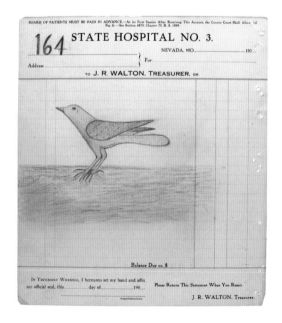

Balance Due us, $..............

In Testimony Whereof, I hereunto set my hand and affix my official seal, this..........day of..........190...

Superintendent.

Please Return This Statement When You Remit.

J. R. WALTON, Treasurer.

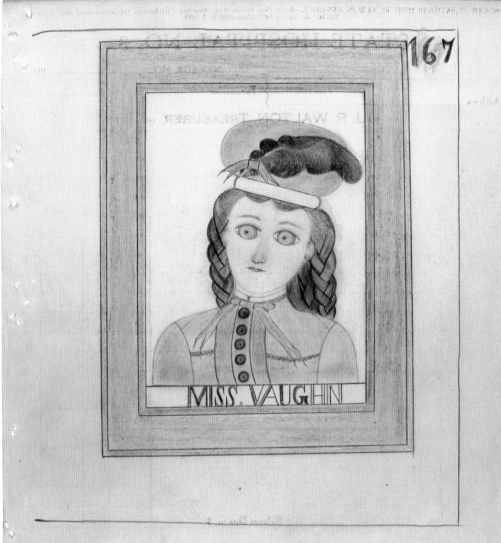

MISS. VAUGHIN

STATE HOSPITAL NO. 3.

168

NEVADA, MO., _____ 190__

Address _____ } For _____

TO J. R. WALTON, TREASURER, DR.

South Tiger

Balance Due us, $

In Testimony Whereof, I hereunto set my hand and affix my official seal, this_____day of_____190____

Superintendent.

Please Return This Statement When You Remit.

J. R. WALTON, Treasurer.

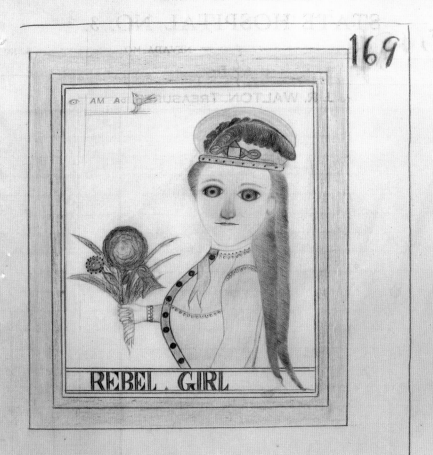

REBEL GIRL

STATE HOSPITAL NO. 3.

170

NEVADA, MO.,_____190__

Address_____ } For_____

TO **J. R. WALTON, TREASURER,** DR.

Balance Due us, $

IN TESTIMONY WHEREOF, I hereunto set my hand and affix
my official seal, this_____day of_____190__

Superintendent.

Please Return This Statement When You Remit.

J. R. WALTON, Treasurer.

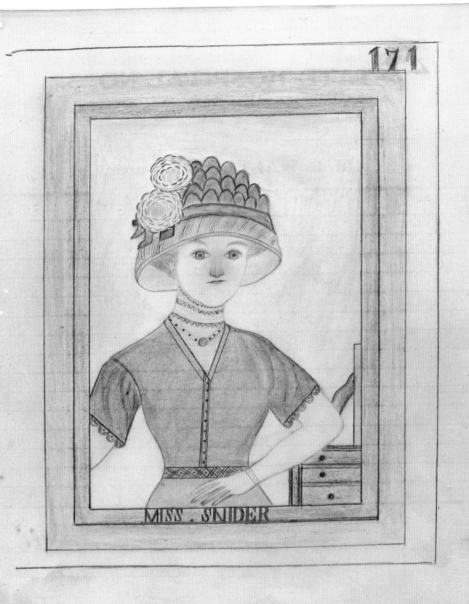

MISS . SNIDER

172

STATE HOSPITAL NO. 3.

Nevada, Mo., _____ 190___

_____ for _____

TO **J. R. WALTON, Treasurer,** DR.

KITTEN

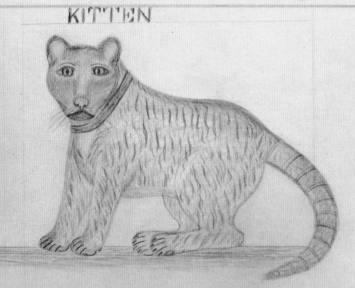

Balance Due us $ _____

In Testimony Whereof, I hereunto set my hand and affix my

official seal, this _____ _day of_ _____ 190___

_____ _Superintendent._

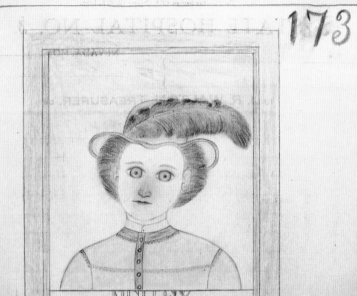

NELLEY

STATE HOSPITAL NO. 3.

174

NEVADA, MO.,_____190___

Address_____ } For_____

TO J. R. WALTON, TREASURER, DR.

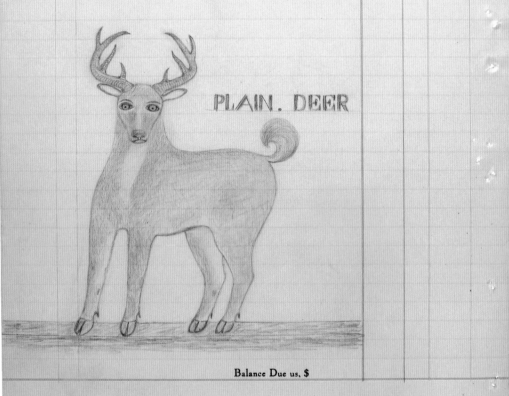

PLAIN. DEER

Balance Due us, $

IN TESTIMONY WHEREOF, I hereunto set my hand and affix my official seal, this_____day of_____190____

Superintendent.

Please Return This Statement When You Remit.

J. R. WALTON, Treasurer.

175

DIXEY
ARKTECTURE

CAT

STATE HOSPITAL NO. 3.

176

NEVADA, MO., _____ 190__

Address _____ } For _____

TO J. R. WALTON, TREASURER, DR.

Balance Due us, $

IN TESTIMONY WHEREOF, I hereunto set my hand and affix my official seal, this_____day of_____190____

Superintendent.

Please Return This Statement When You Remit.

J. R. WALTON, Treasurer.

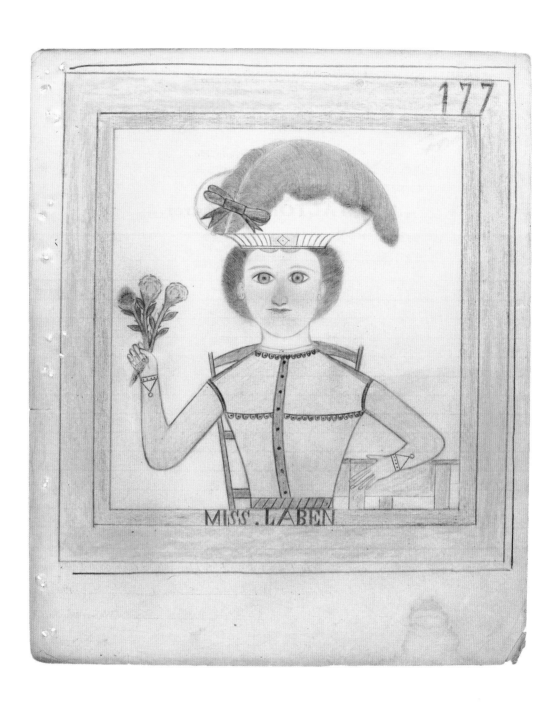

MISS . LABEN

STATE HOSPITAL NO. 3.

178

Nevada, Mo., _____ 190___

for _____

TO **J. R. WALTON, Treasurer,** DR.

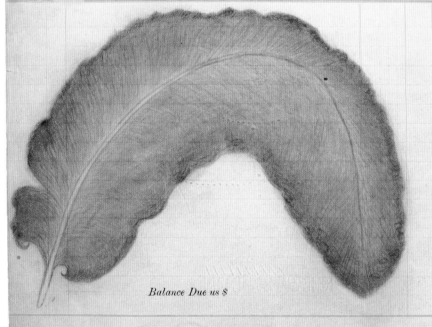

Balance Due us $ _____

In Testimony Whereof, I hereunto set my hand and affix my

official seal, this _____ *day of* _____ *190___*

_____ *Superintendent.*

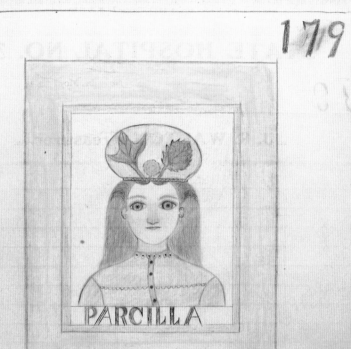

PARCILLA

STATE HOSPITAL NO. 3.

180

Nevada, Mo., _____ 190___

for _____

TO **J. R. WALTON**, Treasurer, DR.

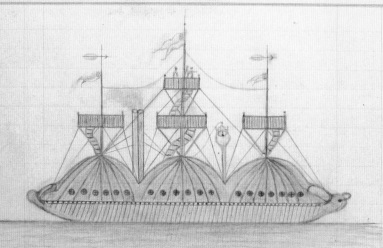

Balance Due us $

In Testimony Whereof, I hereunto set my hand and affix my

official seal, this_____day of_____190___

_____ *Superintendent.*

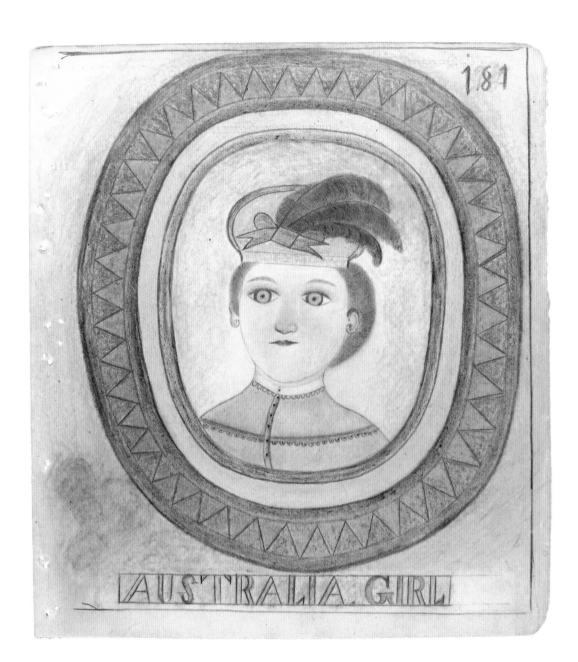

181

AUSTRALIA GIRL

F. A. Derringer, Treas. W. L. Mesplay, Mgr. A. B. Matthews, Sec't

STATE - HOSPITAL
HUNTING & FISHING CLUB.
OFFICE OF TREASURER.

NEVADA, MO,. 191

182

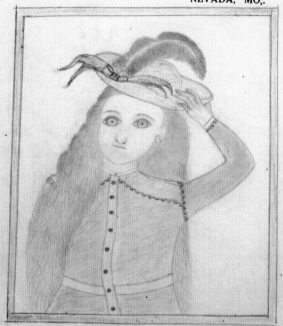

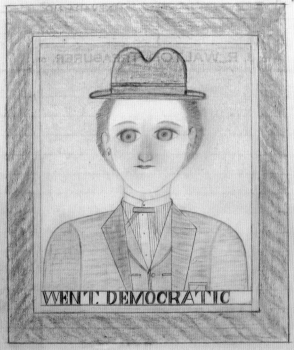

WENT DEMOCRATIC

STATE HOSPITAL NO. 3.

184

NEVADA, MO.,_____ 190__

Address_____ } For_____

TO J. R. WALTON, TREASURER, DR.

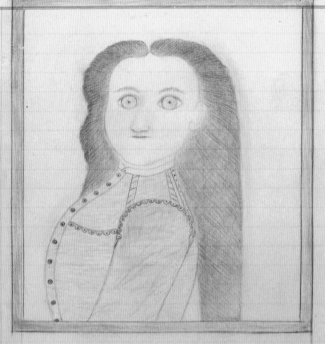

Balance Due us, $

IN TESTIMONY WHEREOF, I hereunto set my hand and affix my official seal, this_____day of_____190___

Please Return This Statement When You Remit.

..
Superintendent.

J. R. WALTON, Treasurer.

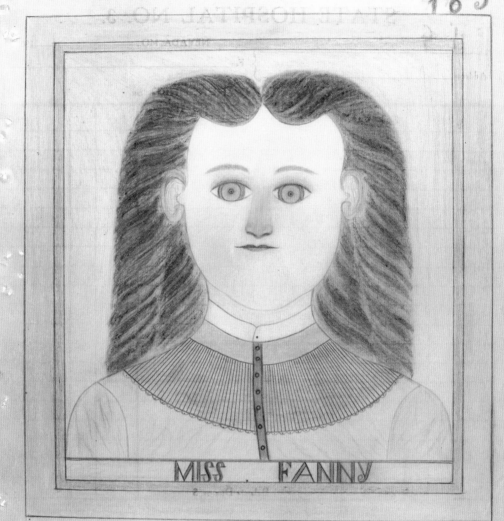

MISS . FANNY

STATE HOSPITAL NO. 3.

186

NEVADA, MO., _____ 190__

Address _____ } For _____

TO J. R. WALTON. TREASURER, DR.

MY DEER

Balance Due us, $ _____

IN TESTIMONY WHEREOF, I hereunto set my hand and affix my official seal, this _____ day of _____ 190__

Superintendent.

Please Return This Statement When You Remit.

J. R. WALTON, Treasurer.

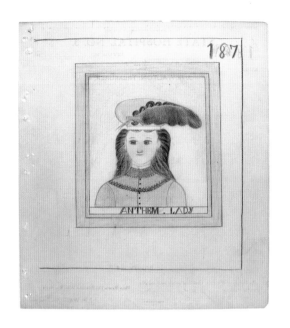

ANTHEM . LADY

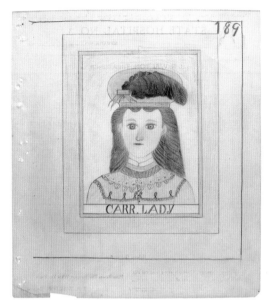

CARR . LADY

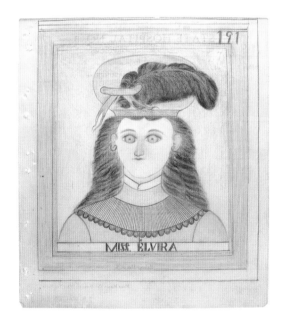

MISS . ELVIRA

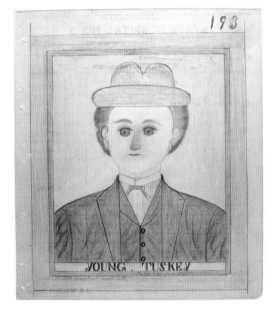

YOUNG . TUSKEY

STATE HOSPITAL NO. 3.

190 NEVADA, MO.................190...

Address................................ } For........................

to J. R. WALTON, TREASURER, DR.

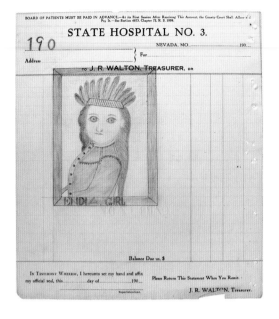

INDIA GIRL

Balance Due us, $

In Testimony Whereof, I hereunto set my hand and affix my official seal, this............day of............190...

Please Return This Statement When You Remit

Superintendent.

J. R. WALTON, Treasurer.

STATE HOSPITAL NO. 3.

188 NEVADA, MO.................190...

Address................................ } For........................

to J. R. WALTON, TREASURER, DR.

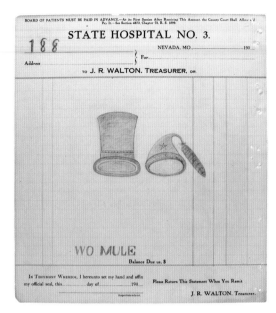

WO MULE

Balance Due us, $

In Testimony Whereof, I hereunto set my hand and affix my official seal, this............day of............190...

Please Return This Statement When You Remit

Superintendent.

J. R. WALTON, Treasurer.

STATE HOSPITAL NO. 3.

194 NEVADA, MO.................190...

Address................................ } For........................

to J. R. WALTON, TREASURER, DR.

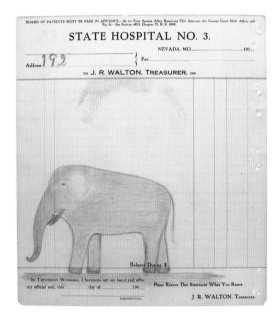

Balance Due us, $

In Testimony Whereof, I hereunto set my hand and affix my official seal, this............day of............190...

Please Return This Statement When You Remit

Superintendent.

J. R. WALTON, Treasurer.

STATE HOSPITAL NO. 3.

NEVADA, MO.................190...

Address 192 } For........................

to J. R. WALTON, TREASURER, DR.

Balance Due us, $

In Testimony Whereof, I hereunto set my hand and affix my official seal, this............day of............190...

Please Return This Statement When You Remit

Superintendent.

J. R. WALTON, Treasurer.

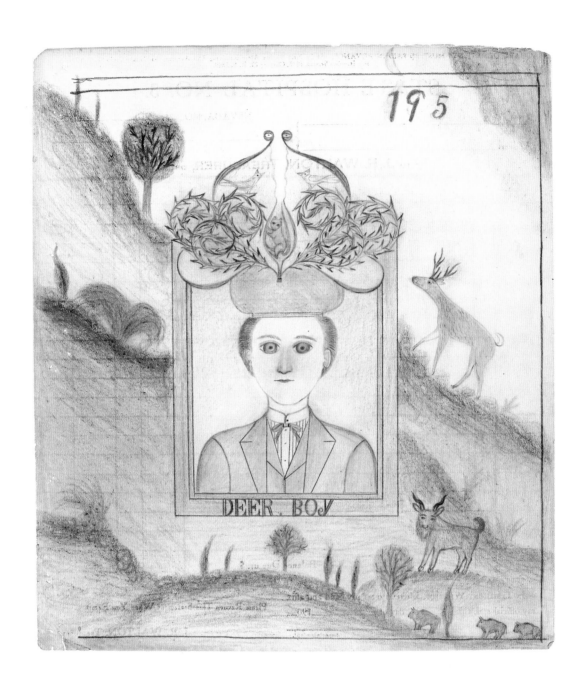

195

DEER. BOY

STATE HOSPITAL NO. 3.

196

NEVADA, MO., _____ 190__

Address _____ } For _____

TO J. R. WALTON, TREASURER, DR.

Balance Due us, $

IN TESTIMONY WHEREOF, I hereunto set my hand and affix my official seal, this _____ day of _____ 190__

Superintendent.

Please Return This Statement When You Remit.

J. R. WALTON, Treasurer.

STATE HOSPITAL NO. 3.

Nevada, Mo.,....................................190....

198

..for...

TO **J. R. WALTON, Treasurer,** DR.

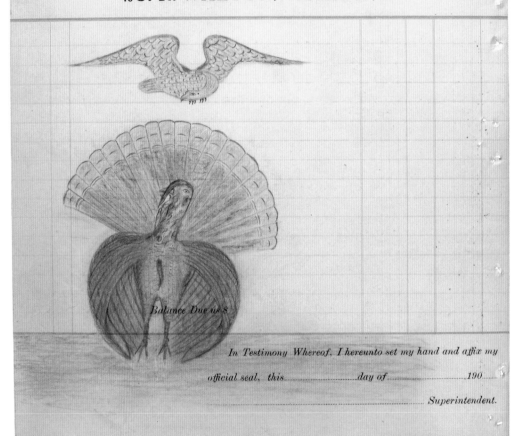

Balance Due us $

In Testimony Whereof, I hereunto set my hand and affix my

official seal, this.........................day of...........................190.....

.. Superintendent.

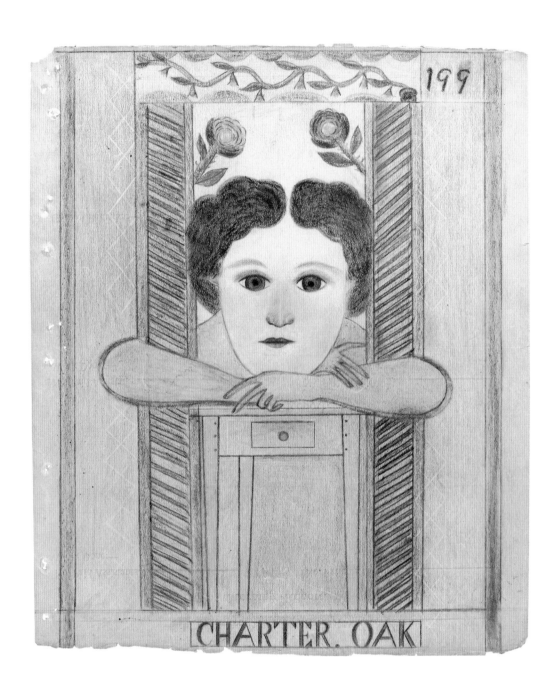

CHARTER. OAK

199

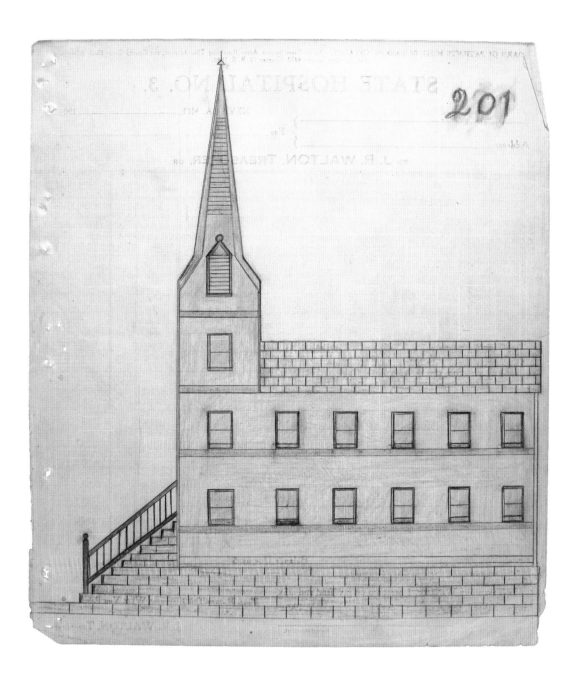

STATE HOSPITAL NO. 3.

202

NEVADA, MO.,_____190__

For_____

Address_____

} For

TO J. R. WALTON. TREASURER, DR.

Balance Due us, $

IN TESTIMONY WHEREOF, I hereunto set my hand and affix my official seal, this_____day of_____190__

Please Return This Statement When You Remit.

Superintendent.

J. R. WALTON, Treasurer.

203

VERV. MOUNTAINEOUS

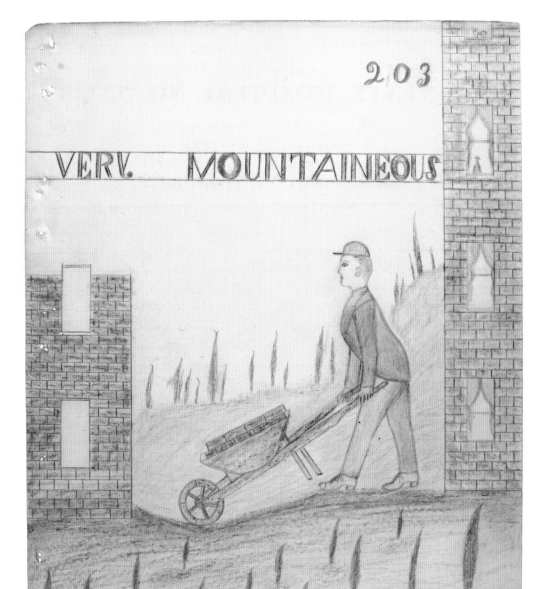

204

STATE HOSPITAL NO. 3.

HOUSE CAT

Nevada, Mo., .. 190....

...for..

TO **J. R. WALTON, Treasurer,** DR.

TIGER

Balance Due us $

In Testimony Whereof, I hereunto set my hand and affix my

official seal, this..................................day of............................190....

.. *Superintendent.*

THE TIGER.S

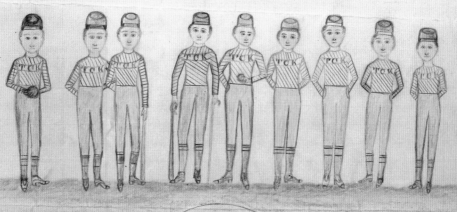

State Lunatic Asylum, No. 3.

Nevada, Mo., _____ 189___

206

ON THE BANKS OF THE OLD TENNISSEE

for

To JOSEPH HARPER, TREASURER, Dr.

J. R. WALTON, Treasurer,

189

Balance due us, $

Approved:

E. and O. E.

IN TESTIMONY WHEREOF, I hereunto set my hand and affix my

official seal, this _____ day of _____ 189___

Superintendent.

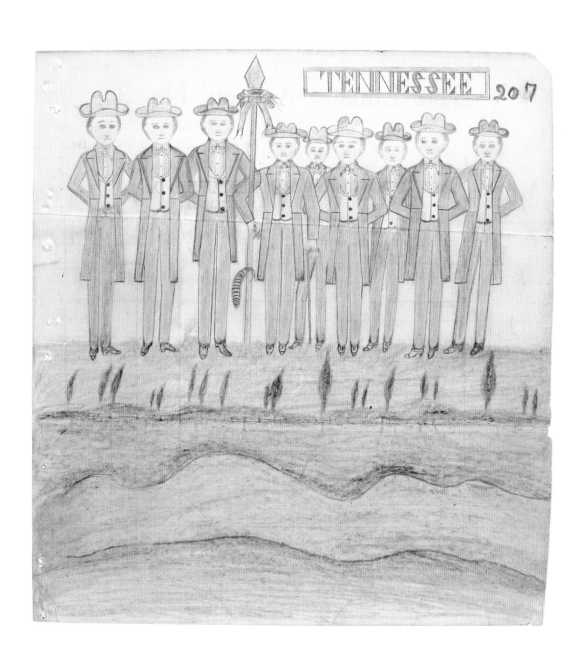

State Lunatic Asylum, No. 3.

Nevada, Mo.,_____ 189____

208

189____

for_____

To JOSEPH HARPER, TREASURER, Dr.

J. R. WALTON, Treasurer.

SODA FOUNTAIN

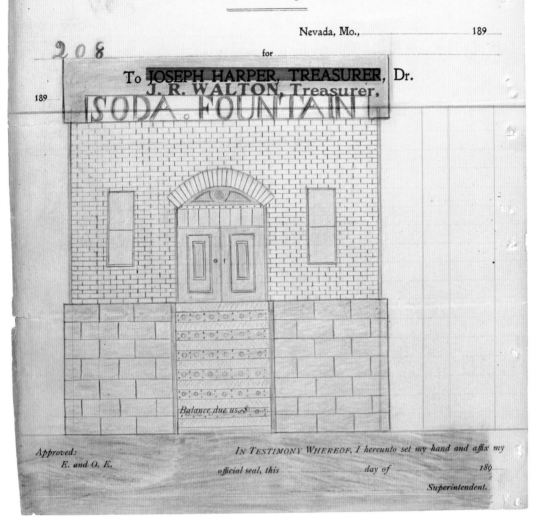

Balance due us, $_____

Approved:

E. and O. E.

IN TESTIMONY WHEREOF, I hereunto set my hand and affix my

official seal, this _____ day of _____ 189____

Superintendent.

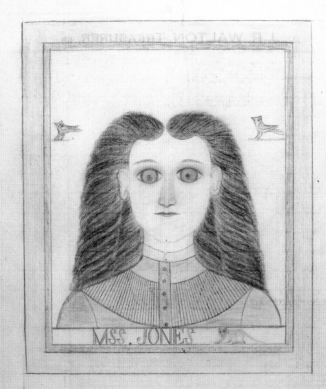

MSS. JONES

STATE HOSPITAL NO. 3.

210

NEVADA, MO.,_____190__

Address_____ } For_____

TO J. R. WALTON, TREASURER, DR.

Balance Due us, $

IN TESTIMONY WHEREOF, I hereunto set my hand and affix my official seal, this_____day of_____190__

Please Return This Statement When You Remit.

Superintendent.

J. R. WALTON, Treasurer.

211

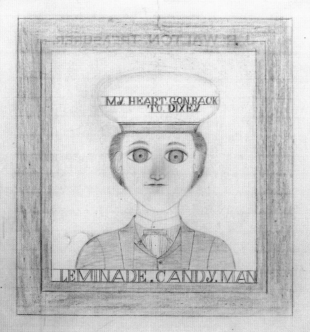

STATE HOSPITAL NO. 3.

212

NEVADA, MO., _____ 190__

Address _____ } For _____

TO **J. R. WALTON, TREASURER,** DR.

Balance Due us, $

IN TESTIMONY WHEREOF, I hereunto set my hand and affix
my official seal, this_____day of_____190____

Please Return This Statement When You Remit.

Superintendent.

J. R. WALTON, Treasurer.

GOOD. HELTH

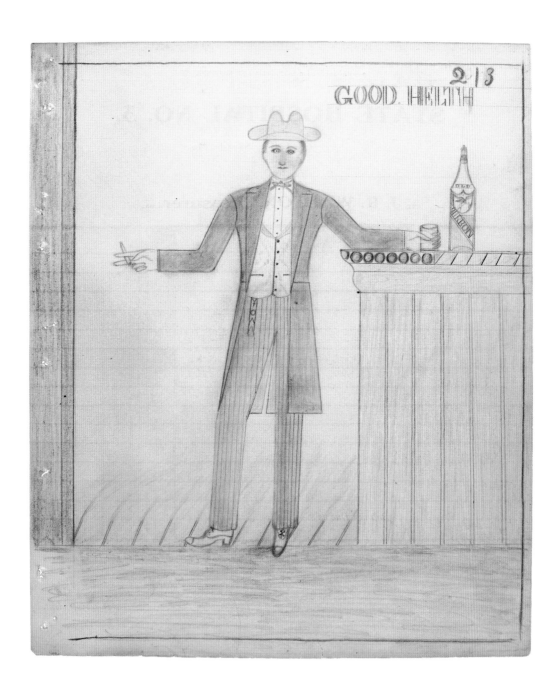

STATE HOSPITAL NO. 3.

Nevada, Mo., _____ 190___

214 _____ for _____

TO **J. R. WALTON, Treasurer,** DR.

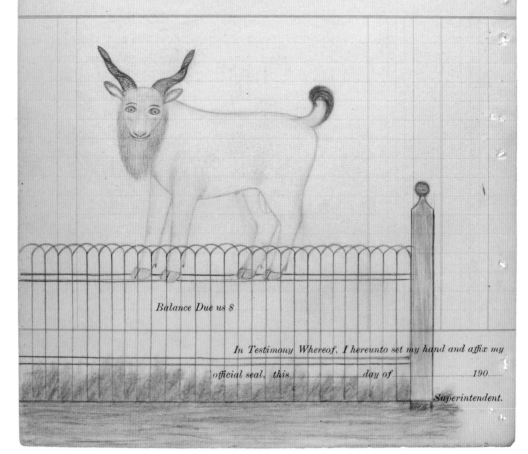

Balance Due us $ _____

In Testimony Whereof, I hereunto set my hand and affix my

official seal, this _____ day of _____ 190___

Superintendent.

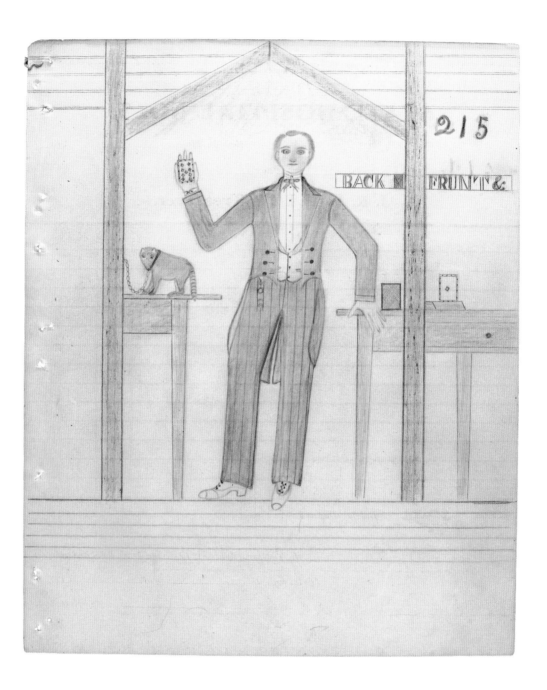

215

BACK M FRUNT &

STATE HOSPITAL NO. 3.

216

Nevada, Mo., _____ 190___

_____ for _____

TO **J. R. WALTON, Treasurer,** DR.

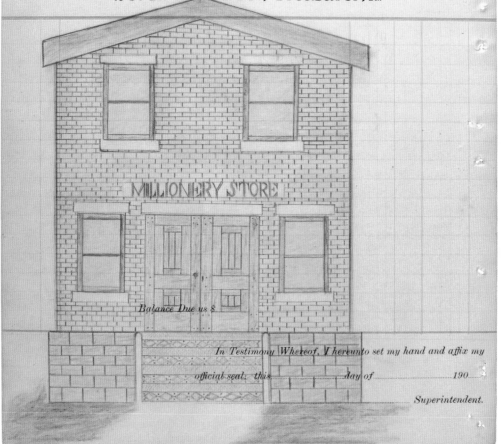

MILLIONERY STORE

Balance Due us $_____

In Testimony Whereof, I hereunto set my hand and affix my

_official seal, this _____ day of _____ 190____

Superintendent.

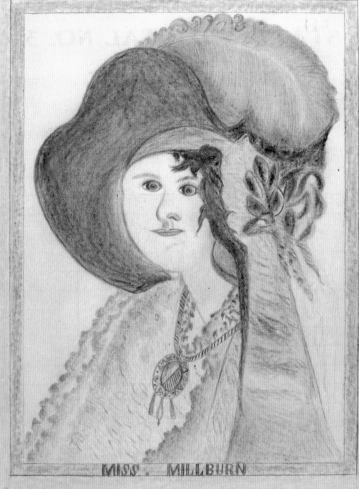

MISS. MILLBURN

STATE HOSPITAL NO. 3.

Nevada, Mo., _____ 190___

218

_____for_____

TO **J. R. WALTON, Treasurer,** DR.

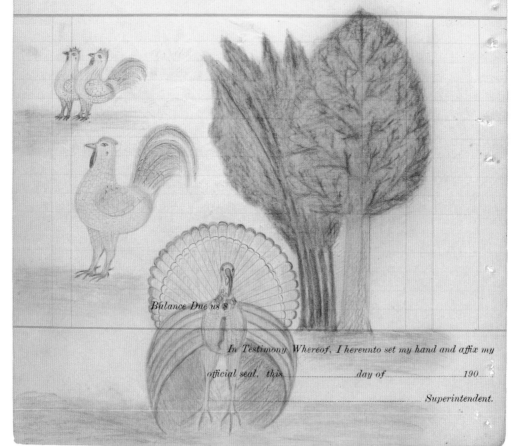

Balance Due us $

In Testimony Whereof, I hereunto set my hand and affix my official seal, this _____ day of _____ 190__

_____ Superintendent.

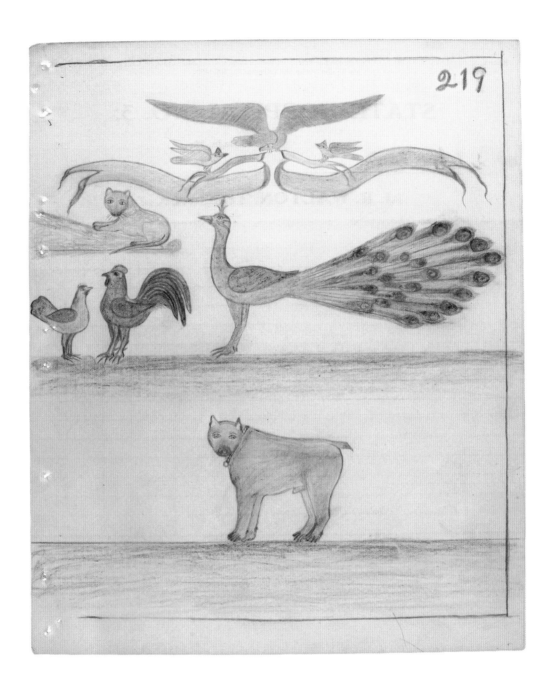

STATE HOSPITAL NO. 3.

Nevada, Mo., _____ 190___

220 _____ for _____

TO **J. R. WALTON**, Treasurer, DR.

Balance Due us $

In Testimony Whereof, I hereunto set my hand and affix my

_official seal, this_____day of_____190____

_____ _Superintendent._

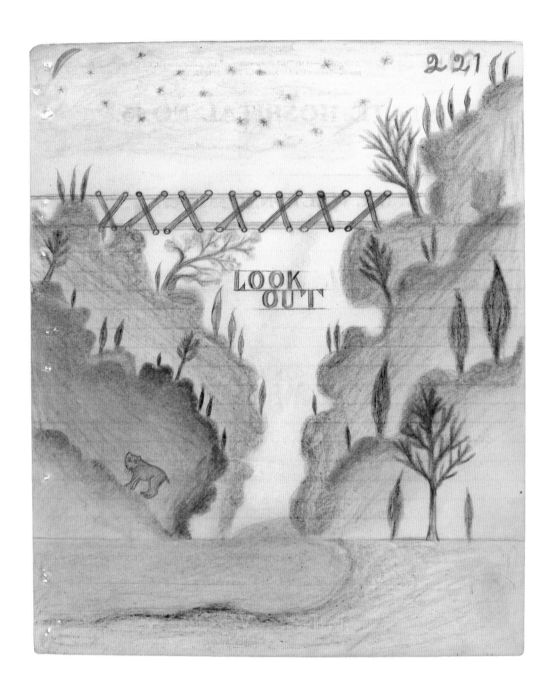

STATE HOSPITAL NO. 3.

Nevada, Mo., _____ 190___

222 _____ for _____

TO **J. R. WALTON, Treasurer,** DR.

Balance Due us $

In Testimony Whereof, I hereunto set my hand and affix my

official seal, this _____ *day of* _____ *190___*

_____ *Superintendent.*

223

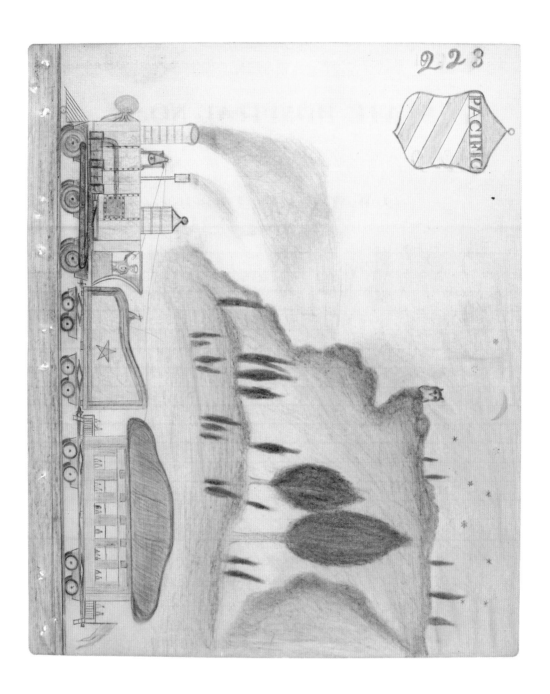

STATE HOSPITAL NO. 3.

Nevada, Mo., _____ 190___

224 _____for_____

TO **J. R. WALTON, Treasurer,** DR.

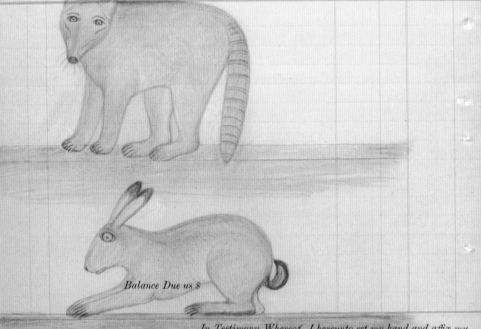

Balance Due us $

In Testimony Whereof, I hereunto set my hand and affix my

_official seal, this_____ _day of_____190___

_____ _Superintendent._

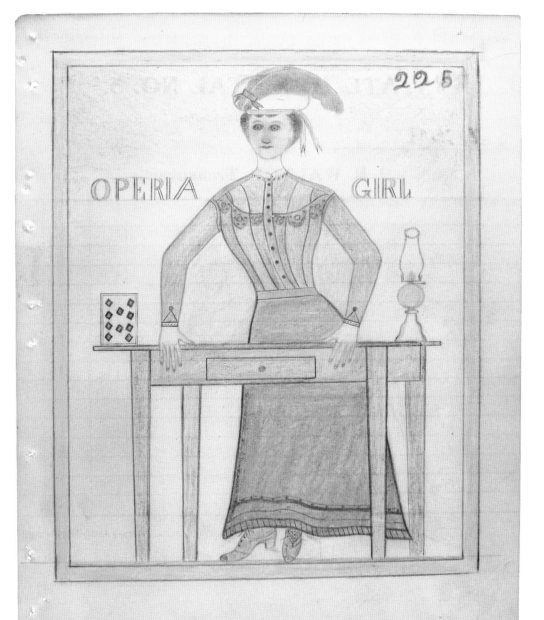

225

STATE HOSPITAL NO. 3.

Nevada, Mo., _____ 190___

226 _____ for _____

To **J. R. WALTON**, Treasurer, DR.

Balance Due us $

In Testimony Whereof, I hereunto set my hand and affix my

_official seal, this_____day of_____190___

Superintendent.

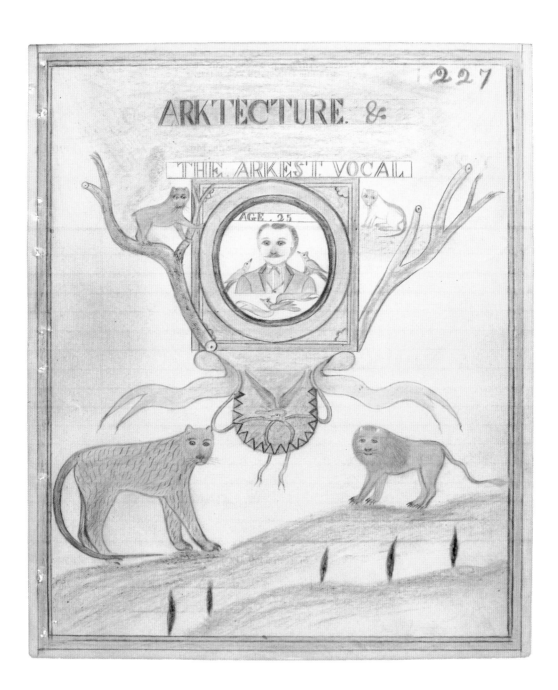

ARKTECTURE. &

THE ARKEST. VOCAL

AGE . 25

STATE HOSPITAL NO. 3.

Nevada, Mo., _____ 190___

228 _____for_____

TO **J. R. WALTON, Treasurer,** DR.

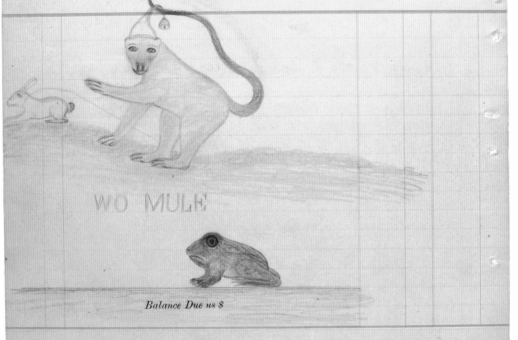

Balance Due us $

In Testimony Whereof, I hereunto set my hand and affix my

official seal, this_____day of_____190___

_____ *Superintendent.*

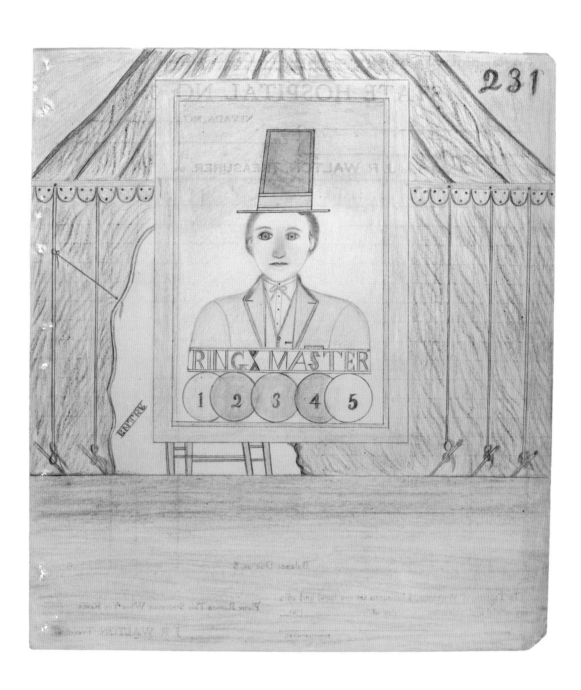

STATE HOSPITAL NO. 3.

NEVADA, MO.,_____190___

Address **232** } For_____

TO **J. R. WALTON, TREASURER,** DR.

RABIANSD

Balance Due us, $

IN TESTIMONY WHEREOF, I hereunto set my hand and affix my official seal, this_____day of_____190____

Superintendent.

Please Return This Statement When You Remit.

J. R. WALTON, Treasurer.

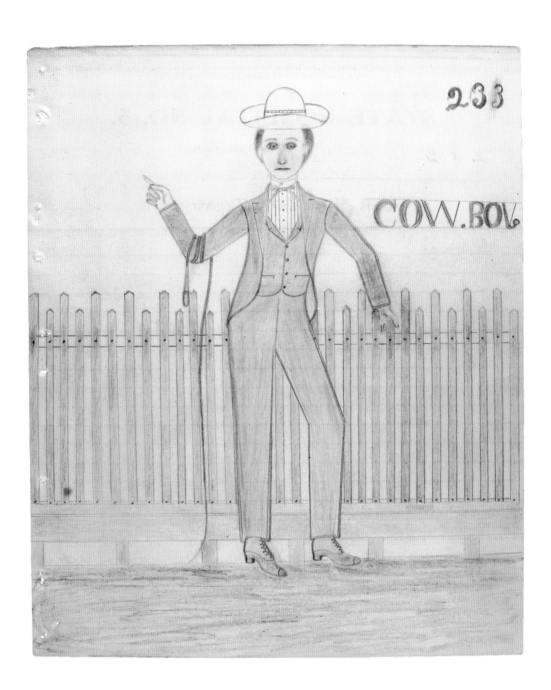

233

COW.BOY

STATE HOSPITAL NO. 3.

Nevada, Mo., _____ 190____

234 _____ for _____

TO **J. R. WALTON, Treasurer,** DR.

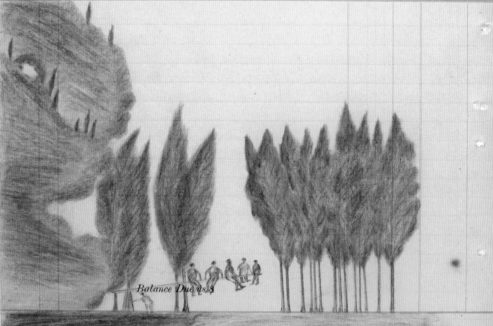

Balance Due $8.8

In Testimony Whereof, I hereunto set my hand and affix my

official seal, this _____ *day of* _____ *190____*

_____ *Superintendent.*

QUINN 235

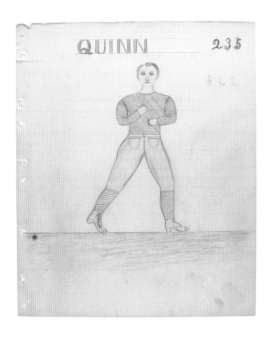

MONT. STELLA 237
LIGHT. WEIGHT

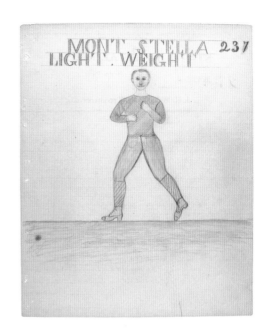

239

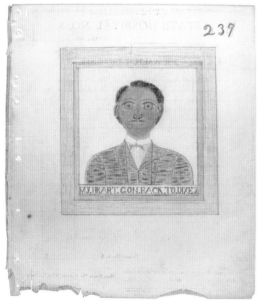

MY. HEART. GON. BACK. TO. DIXEY.

241

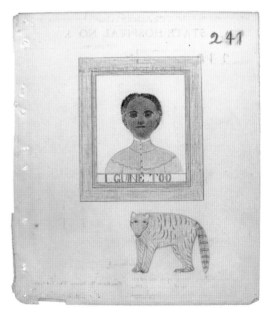

I. GUNE. TOO

STATE HOSPITAL NO. 3.

Nevada, Mo., _____ 190_

238 _____ for _____

to **J. R. WALTON**, Treasurer, Dr.

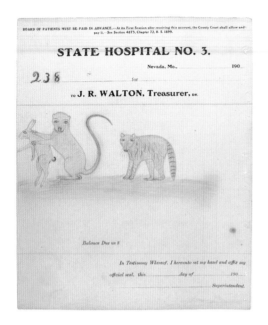

Balance Due us 8

In Testimony Whereof, I hereunto set my hand and affix my

official seal, this _____ day of _____ 190_

_____ Superintendent.

STATE HOSPITAL NO. 3.

Nevada, Mo., _____ 190_

236 _____ for _____

to **J. R. WALTON**, Treasurer, Dr.

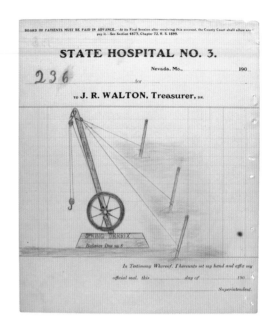

Balance Due us 8

In Testimony Whereof, I hereunto set my hand and affix my

official seal, this _____ day of _____ 190_

_____ Superintendent.

STATE HOSPITAL NO. 3.

NEVADA, MO. _____ 190_

Address 242 } For _____

to **J. R. WALTON**, TREASURER, Dr.

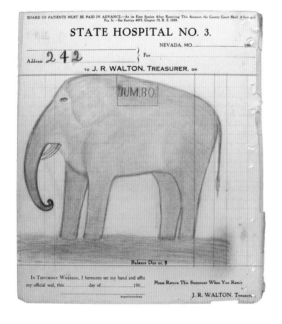

Balance Due us, $

In Testimony Whereof, I hereunto set my hand and affix

my official seal, this _____ day of _____ 190_

_____ Superintendent.

Please Return This Statement When You Remit

J. R. WALTON, Treasurer

STATE HOSPITAL NO. 3.

NEVADA, MO. _____ 190_

Address 240 } For _____

to **J. R. WALTON**, TREASURER, Dr.

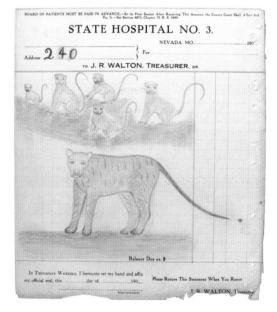

Balance Due us, $

In Testimony Whereof, I hereunto set my hand and affix

my official seal, this _____ day of _____ 190_

_____ Superintendent.

Please Return This Statement When You Remit

J. R. WALTON, Treasurer

STATE HOSPITAL NO. 3.

NEVADA, MO.,_____ 243 ____190__

24

Address _____

} For _____

то **J. R. WALTON, TREASURER,** DR.

GOING TO PIKES PEAK

Balance Due us, $

In Testimony Whereof, I hereunto set my hand and affix
my official seal, this_____ day of_____190____

Superintendent.

Please Return This Statement When You Remit.

J. R. WALTON, Treasurer

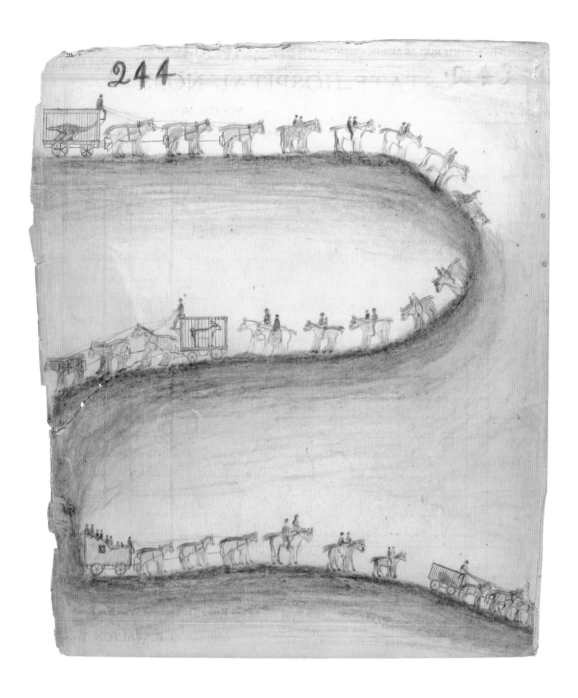

STATE HOSPITAL NO. 3.

2 4

NEVADA, MO., _____ 190

Address _____ } For _____

TO J. R. WALTON, TREASURER, DR.

Balance Due us, $

IN TESTIMONY WHEREOF, I hereunto set my hand and affix
my official seal, this _____ day of _____ 190___

Please Return This Statement When You Remit.

Superintendent,

J. R. WALTON, Tre

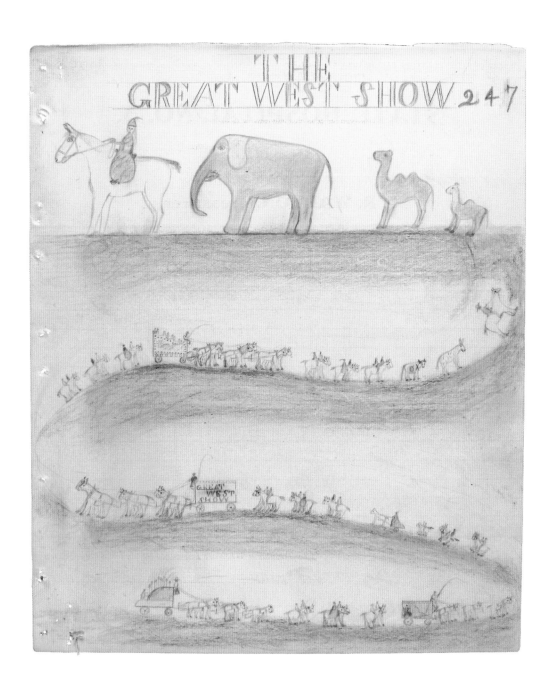

STATE HOSPITAL NO. 3.

Nevada, Mo., _____ 190

248

_____ for _____

то **J. R. WALTON, Treasurer,** DR.

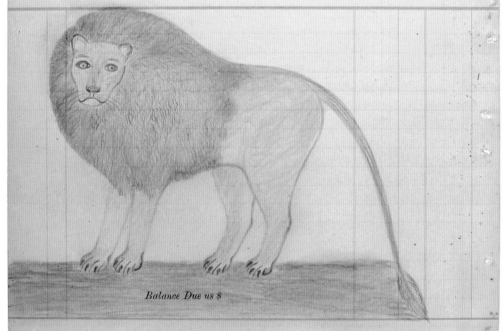

Balance Due us $

In Testimony Whereof, I hereunto set my hand and affix my

official seal, this _____ day of _____ 190_____

_____ Superintendent.

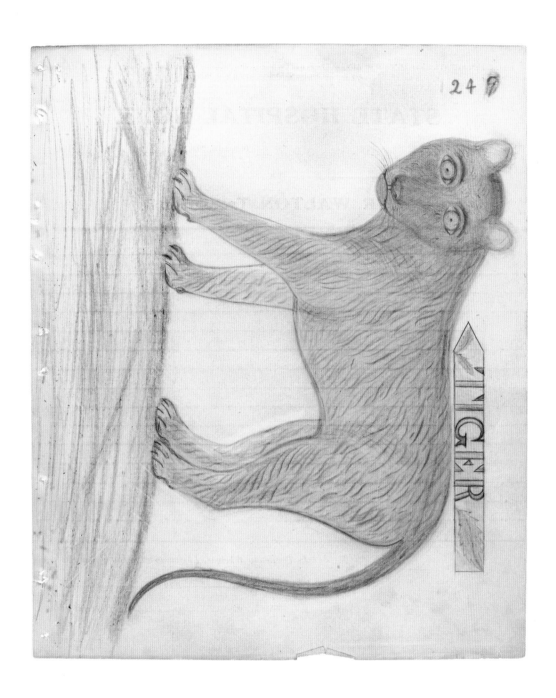

STATE HOSPITAL NO. 3.

Nevada, Mo., _____ 190___

250

................................for................................

TO **J. R. WALTON, Treasurer,** DR.

SPECKEL TROUT

Balance Due us $

In Testimony Whereof, I hereunto set my hand and affix my

official seal, this_____day of_____190___

_____ *Superintendent.*

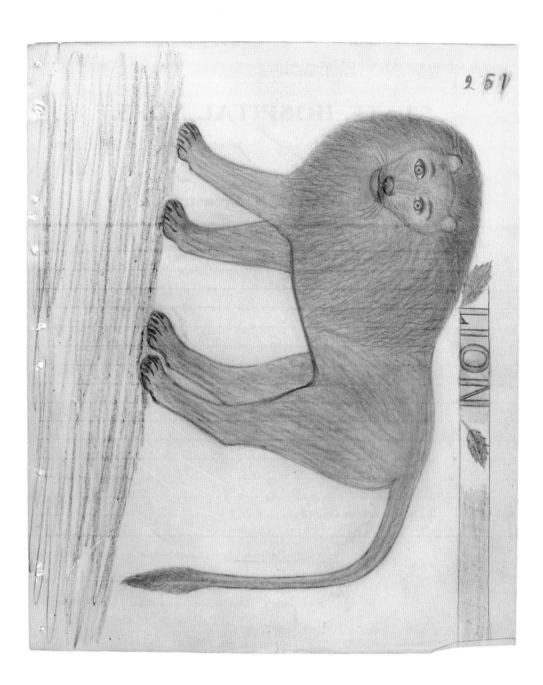

LION

STATE HOSPITAL NO. 3.

Nevada, Mo., _____ 190___

2 52 _____ for _____

TO **J. R. WALTON, Treasurer,** DR.

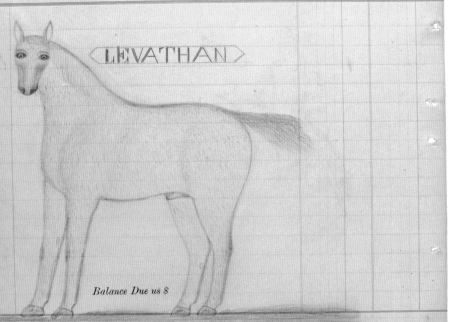

LEVATHAN

Balance Due us $

In Testimony Whereof, I hereunto set my hand and affix my

official seal, this _____ _day of_ _____ _190___

_____ _Superintendent._

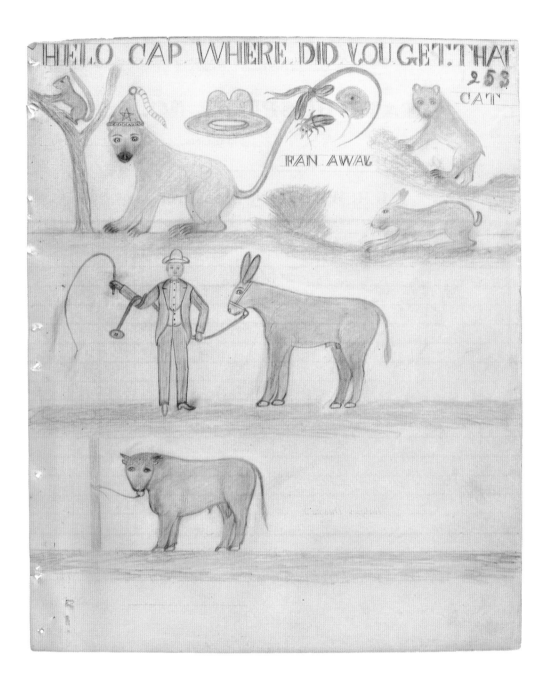

STATE HOSPITAL NO. 3.

A PORTION OF BOSTON MOUNTAIN

254

Nevada, Mo., 190

for

To **J. R. WALTON, Treasurer,** Dr.

Balance Due us $

In Testimony Whereof, I hereunto set my hand and affix my

official seal, this _____ day of _____ 190___

_____ Superintendent.

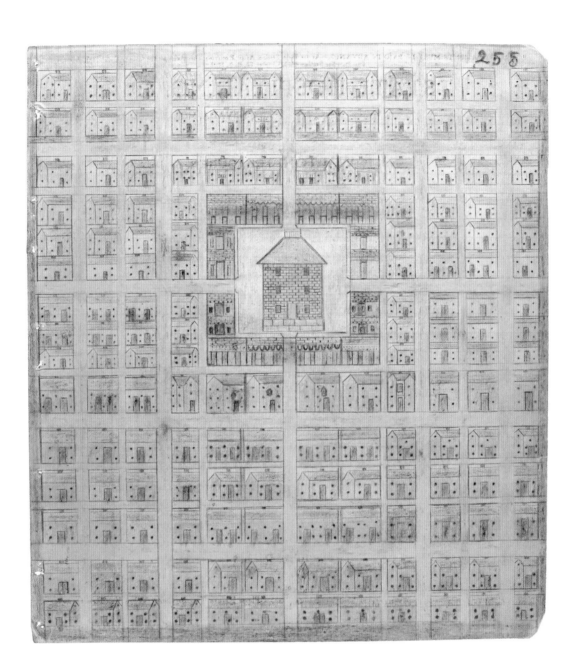

STATE HOSPITAL NO. 3.

256

NEVADA, MO.,_____ 190__

Address _____ } For _____

TO J. R. WALTON, TREASURER, DR.

Balance Due us, $

IN TESTIMONY WHEREOF, I hereunto set my hand and affix my official seal, this_____day of_____190___

Superintendent.

Please Return This Statement When You Remit.

J. R. WALTON, Treasurer.

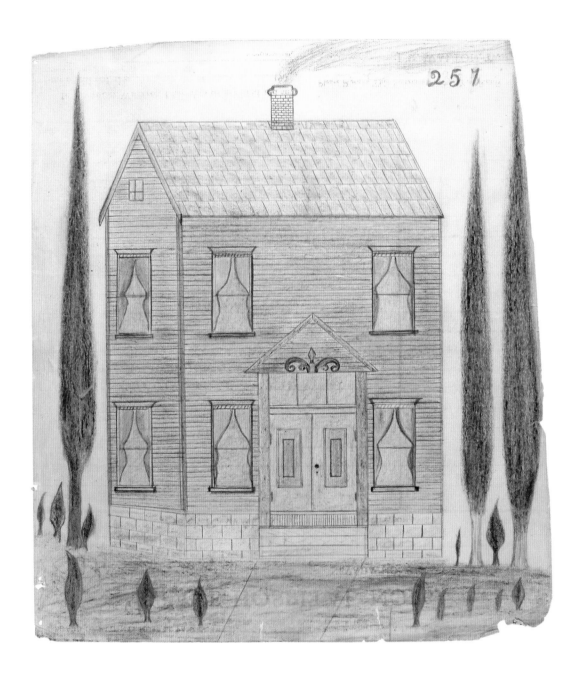

257

STATE HOSPITAL NO. 3.

NEVADA, MO., _____ 190__

_____ } For _____

Address _____

TO J. R. WALTON, TREASURER, DR.

GARDEN WORK

Balance Due us, $ _____

258

IN TESTIMONY WHEREOF, I hereunto set my hand and affix my official seal, this_____ day of_____190____

Please Return This Statement When You Remit.

Superintendent.

J. R. WALTON, Treasu

259

STATE HOSPITAL NO. 3.

NEVADA, MO.,_____190___

Address _260_ } For _____

TO J. R. WALTON. TREASURER, DR.

THE GALE

Balance Due us, $

IN TESTIMONY WHEREOF, I hereunto set my hand and affix
my official seal, this_____day of_____190___

Please Return This Statement When You Remit.

Superintendent.

J. R. WALTON, Treasurer.

261

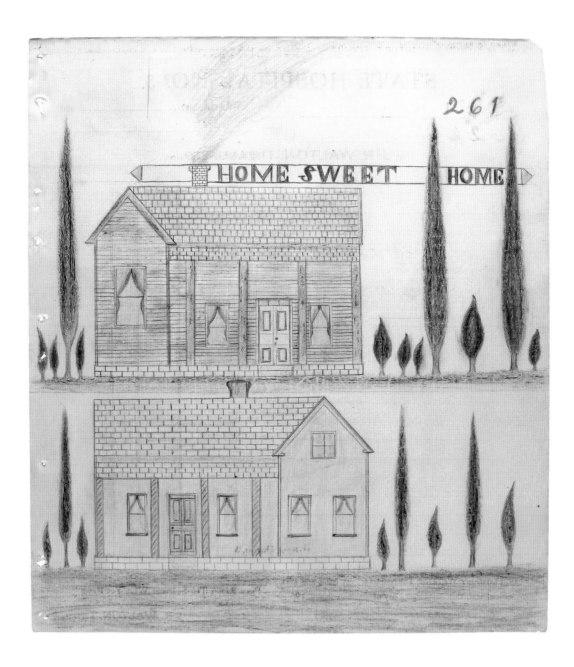

STATE HOSPITAL NO. 3.

NEVADA, MO.,_____190__

Address _262_____ } For_____

TO **J. R. WALTON, TREASURER,** DR.

Balance Due us, $

IN TESTIMONY WHEREOF, I hereunto set my hand and affix
my official seal, this_____day of_____190__

Please Return This Statement When You Remit.

Superintendent.

J. R. WALTON, Treasurer.

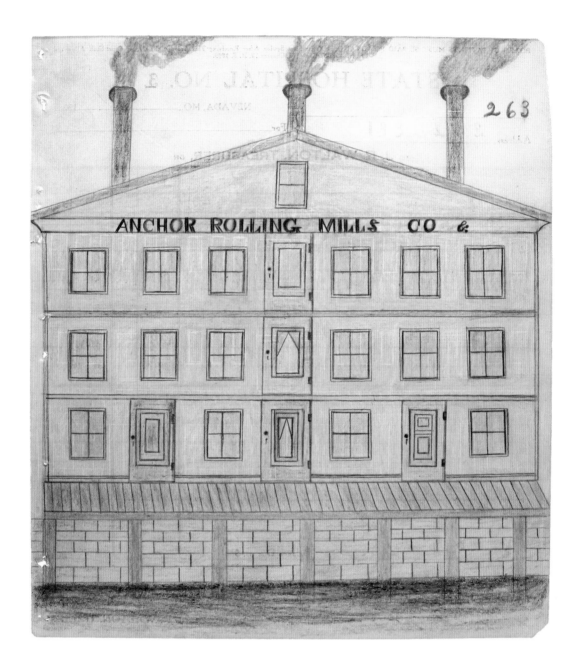

STATE HOSPITAL NO. 3.

NEVADA, MO.,_____190__

Address ___2 6 4_____ } For_____

TO J. R. WALTON, TREASURER, DR.

MERINER

Balance Due us, $

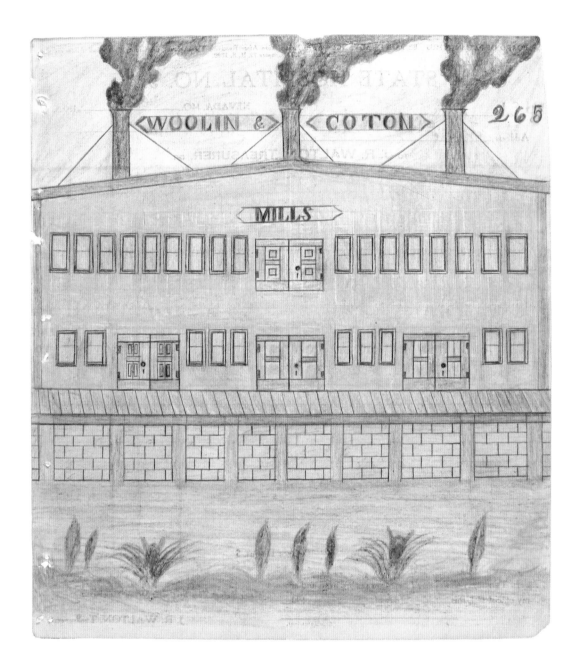

STATE HOSPITAL NO. 3.

NEVADA, MO.,_____ 190__

Address **266** } For_____

TO **J. R. WALTON, TREASURER,** DR.

SOUTHREN HOTELL CO

Balance Due us, $

IN TESTIMONY WHEREOF, I hereunto set my hand and affix my official seal, this_____ day of_____ 190__

Please Return This Statement When You Remit

Superintendent.

J. R. WALTON, Trasurer.

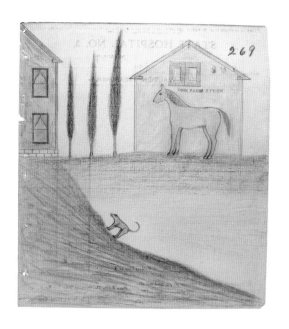

269

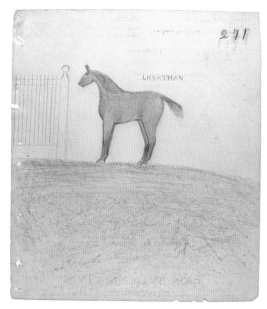

271

LEVATHAN

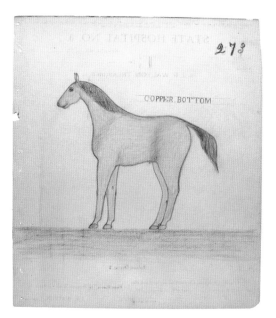

273

COPPER.BOTTOM

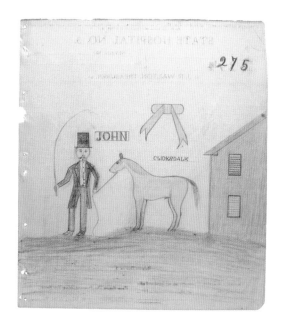

275

JOHN

CLIDESDALE

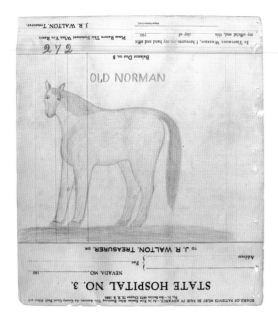

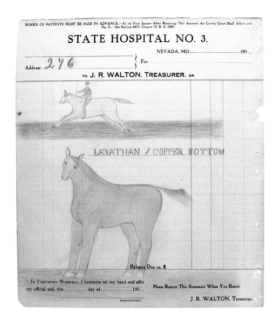

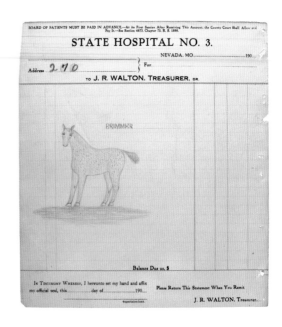

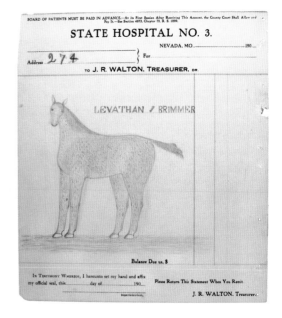

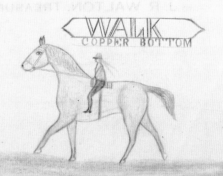

WALK
COPPER BOTTOM

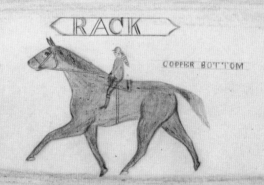

RACK

COPPER BOTTOM

STATE HOSPITAL NO. 3.

NEVADA, MO.,_____190__

Address **278** } For_____

TO **J. R. WALTON, TREASURER,** DR.

TALK. ABOUT. NONSINCE

BRIMMER

Balance Due us, $

IN TESTIMONY WHEREOF, I hereunto set my hand and affix my official seal, this_____day of_____190____

Superintendent.

Please Return This Statement When You Remit.

J. R. WALTON, Treasurer.

IRON. GRAY.

LEVATHAN

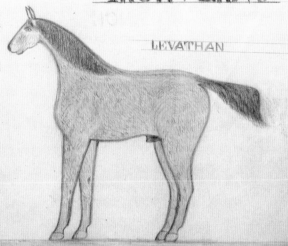

STATE HOSPITAL NO. 3.

NEVADA, MO.,_____190__

Address *2 8 0* } For_____

TO J. R. WALTON, Treasurer, DR.

BRIMMER

Balance Due us, $

IN TESTIMONY WHEREOF, I hereunto set my hand and affix my official seal, this_____day of_____190__

Superintendent.

Please Return This Statement When You Remit.

J. R. WALTON, Treasurer.

DEXTER

LEVATHAN and BRIMMER

STATE HOSPITAL NO. 3.

282

NEVADA, MO.,_____190_

Address_____ } For_____

TO **J. R. WALTON, TREASURER,** DR.

Balance Due us, $

IN TESTIMONY WHEREOF, I hereunto set my hand and affix

my official seal, this_____day of_____190_

Superintendent.

Please Return This Statement When You Remit.

J. R. WALTON, Treasurer.

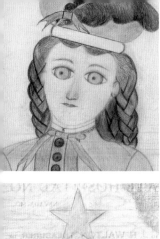
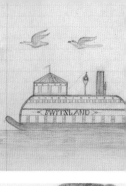
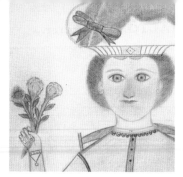
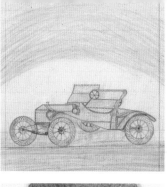

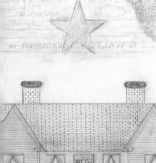
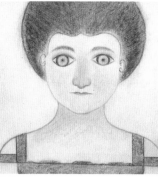
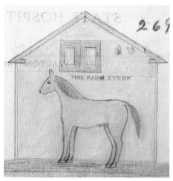
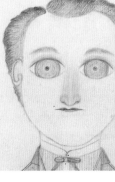

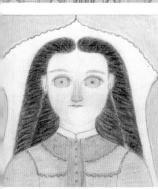

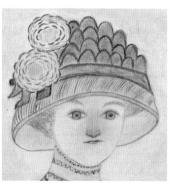
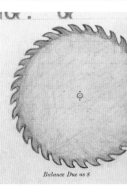

Balance Due us $

Balance Due us $

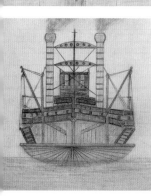
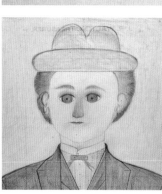
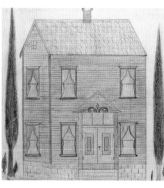
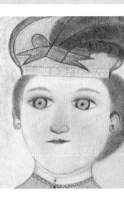

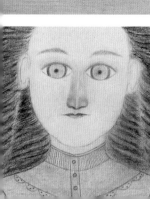
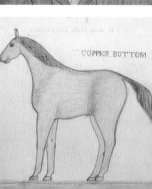
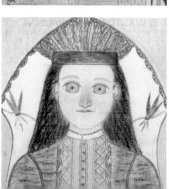
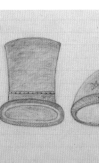

COPPER BOTTOM

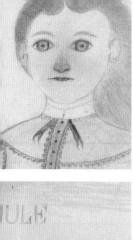
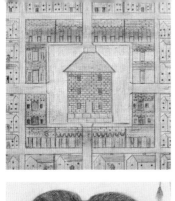
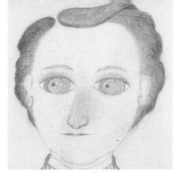
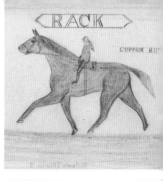
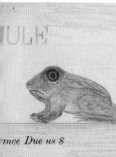
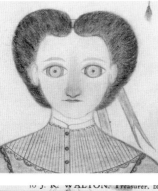
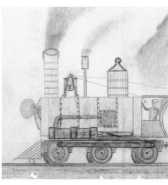
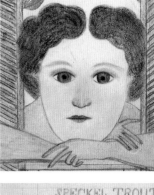
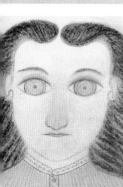
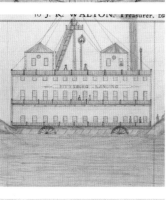
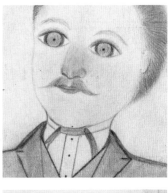
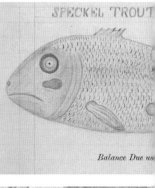
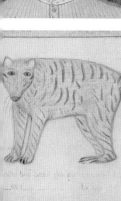
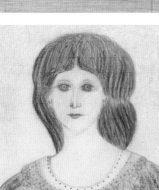
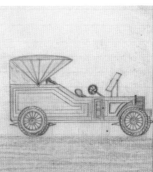
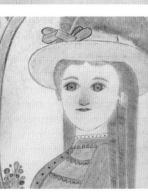
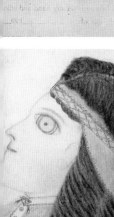
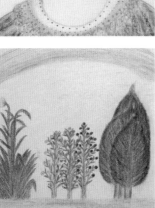
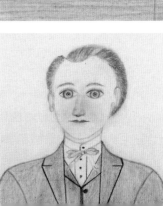
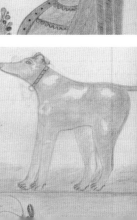

Published by
Princeton Architectural Press
37 East Seventh Street
New York, New York 10003

Visit our website at www.papress.com

Editor: Sara Stemen
Designer: Paul Wagner
Design Assistance: Jimin Park

Special thanks to: Nicola Bednarek Brower, Janet Behning,
Erin Cain, Tom Cho, Barbara Darko, Benjamin English,
Jenny Florence, Jan Cigliano Hartman, Jan Haux, Lia Hunt, Mia Johnson,
Valerie Kamen, Simone Kaplan-Senchak, Stephanie Leke, Diane Levinson,
Jennifer Lippert, Sara McKay, Jaime Nelson Noven, Rob Shaeffer,
Kaymar Thomas, Joseph Weston, and Janet Wong of
Princeton Architectural Press —Kevin C. Lippert, publisher

Library of Congress Cataloging-in-Publication Data
Deeds, Edward, 1908–1987.
[Drawings]
The Electric Pencil / James Edward Deeds Jr. ;
Introduction by Richard Goodman.
pages cm
ISBN 978-1-61689-454-2 (alk. paper)
1. Deeds, Edward, 1908–1987—Notebooks, sketchbooks, etc.
2. Art brut—United States.
3. Outsider art—United States.
I. Goodman, Richard, 1945–writer of introduction. II. Title.
NC139.D43A4 2016
741.973—dc23